WHITEWALLING

WHITEWALLING
ART, RACE & PROTEST IN 3 ACTS

ARUNA D'SOUZA

ARTWORK BY
PARKER BRIGHT & PASTICHE LUMUMBA

Badlands Unlimited
New York

Whitewalling: Art, Race & Protest in 3 Acts
by Aruna D'Souza

First printing

Published by:
Badlands Unlimited
P.O. Box 151
New York, NY, 10002
(646) 478-8653
operator@badlandsunlimited.com
www.badlandsunlimited.com

Enhanced e-book with multimedia content available on Apple iBooks and Amazon
Kindle. For more information, visit www.badlandsunlimited.com.

Editor: Paul Chan
Assistant editor: Micaela Durand
Production and outreach: Parker Bruce
Fact-checker: Ania Szremski
Copy editor: Claire Lehmann
Book designer: Paul Chan

Paper book distributed in the Americas by:
ARTBOOK | D.A.P.
75 Broad Street, Suite 630
New York, NY 10004
Phone: (800) 338-BOOK; Fax: (212) 627-9484
www.artbook.com

Paper book distributed in Europe by:
Buchhandlung Walther König
Ehrenstraße 4
50672 Köln
Germany
www.buchhandlung-walther-koenig.de

Printed in the United States of America

ISBN: 978-1-943263-14-1
E-Book ISBN: 978-1-943263-18-9

www.badlandsunlimited.com

*To my friend Linda Nochlin
and my grandmother Sita Lala,
two women who showed me that
what is right is always
better than what
is safe.*

Contents

List of illustrations .. 1

Setting the stage .. 3

Act 1: *Open Casket,*
 Whitney Biennial, 2017 15

Act 2: *The Nigger Drawings,*
 Artists Space, 1979 65

Act 3: *Harlem on My Mind,*
 Metropolitan Museum of Art, 1969 105

Acknowledgments ... 147

List of illustrations

14 Parker Bright, *Confronting My Own Possible Death*, 2018. Mixed media on paper, 19 x 24 in. Courtesy of the artist.

52 Pastiche Lumumba, *Expanding Brain Dana Schutz Open Casket*, 2017. Meme. Courtesy of the artist.

64 Parker Bright, *Coward$*, 2018. Mixed media on paper, 24 x 19 in. Courtesy of the artist.

104 Parker Bright, *No Show*, 2018. Mixed media on paper, 19 x 24 in. Courtesy of the artist.

126 Thomas Patsenka, *Protest at the Metropolitan Museum of Art*, January 12, 1969. Photograph. Courtesy of the artist.

SETTING THE STAGE

When I set out in the summer of 2017 to write a book about art, race, and protest, there was already more than enough to grapple with. Major controversies had erupted during the previous ten months, spilling over from the relatively small and bounded space of the "art world" (an already amorphous network of artists, critics, art historians, gallerists, museum types, and other interested parties) into a set of much larger conversations in the porous space of social media. In September 2016, residents had expressed anger at an exhibition at the Contemporary Art Museum St. Louis—just miles from the site of the Ferguson protests two years prior—of Kelley Walker's work, which deploys images of black bodies in equivocal, even out-

right abject, ways. The following May, Sam Durant's *Scaffold*, a large outdoor structure that included representations of the gallows used to hang thirty-eight Dakota men in 1862, on which visitors to the Walker Art Center in Minneapolis could climb, was accused by Native activists of trivializing the largest mass execution in US history and a signal event in the long process of US genocide of indigenous populations. In June, long-standing challenges by Native art historians' and artists' to the artist Jimmie Durham's claims of Cherokee heritage gained traction as a major retrospective of his work traveled to the embattled Walker. In September, animal-rights activists started a petition that has by now garnered over eight hundred thousand signatures, demanding that the Guggenheim remove works that were deemed abusive to animals from their upcoming survey of Chinese contemporary art. Even as I was writing the final words of this book in December 2017, amid the intensity of the #MeToo movement targeting sexual abusers and in the wake of revelations that Roy Moore, a GOP candidate in the Alabama Senate race, had sexually abused a number of young girls, a petition circulated asking the Metropolitan Museum of Art in New York to reconsider their display of a notorious painting by the French artist Balthus that thematizes pedophiliac desire.

And, of course, there was the controversy to end all controversies, the decision of the curators of the 2017 Whitney Biennial, one of the most-watched events in the US art world, to include a painting by

the white artist Dana Schutz depicting the brutally lynched body of the young Emmett Till in his coffin.

There was no end of examples to include. But even more urgently, the issues being raised in the debates around each of these cases were entwined in a much larger set of conversations—although *conversations* seems like too polite a term—about some of the most fundamental pieties and values of liberal thought. How to discuss questions of cultural appropriation (in other words, the questions of what histories to engage, how to engage them, and who is best to engage them) and of free speech, without also talking about whether Milo Yiannopoulos or Richard Spencer, notorious white supremacists, should be allowed to speak on college campuses; or whether the mass-produced statues of Confederate "heroes" installed during the Jim Crow era in the South should now, finally, be taken down? How to think about these issues without also thinking about contemporary violence being visited on black and brown bodies, the possibilities and limits of protest, and whether it's okay to punch a Nazi? How to approach the question of what art institutions hang on their walls without asking about the responsibilities of institutions—all manner of institutions—to make space for everyone, or at least to be honest about whom they are built to serve? How to talk about any of these cases without seeing them as manifestations of the activism around Black Lives Matter, Standing Rock, and #MeToo?

To complicate matters further, the form of

many of these protests vastly exceeded any physical gathering of people—they were happening through Facebook debates, Instagram posts, Twitter flame wars, viral memes, and articles with inflammatory titles that often went unread in their entirety, and so on. It has become easy for people to lament the degradation of discourse due to social media, especially in the wake of the 2016 US presidential election, when we discovered how fake news could be taken for real and how algorithms could generate outrage and unwavering belief by turns. And to be sure, social media's usefulness as a space of protest is fraught—encouraging "clicktivism" and easily expressed solidarity or condemnation that need never be tested in one's off-line interactions. But it is also a space in which thoughts first become visible, in which people who might never otherwise have the opportunity or interest in forming an opinion on a given topic—especially on questions of art's place in political discourse—are encouraged to do so, if only because all those social media platforms coerce us to participate by their very structure. I have no doubt that for the vast majority of people who weighed in on any one of these controversies, it was the first time they had ever expressed a judgment about what art should be able to do or say. That itself seems like something to think about further.

But while everything about these various art-centric protests seems perfectly keyed to our moment—to the present—none of this is new. What many are calling our new culture war is imagined to

be a reiteration of those that came before—the outrage stirred up by then-Mayor Rudy Giuliani against Chris Ofili's painting *The Holy Virgin Mary* (1996) when it was shown at the Brooklyn Museum in 1999, or the early 1990s attack by right-wing politicians like Jesse Helms against the "immoral" art being supported by the National Endowment for the Arts—with the same whiffs of a reactionary and stifling puritanism that went along with both.

But to see our current culture war as a mere repetition of previous ones is to misrecognize how they are alike and how they are emphatically different. What all of these events do have in common is that they were moments of reckoning. Institutions of public culture were being forced to rethink how they conceive of their publics: who they represent, whose interests they serve. The crucial difference is that the first type of culture war is a war on culture by those who exploit the financial and legislative power of the state to demonize art, attack artists, and defund institutions for political gain. The second type is a war to expand the terms of culture by those who are largely artists, and who want to participate fully in the art world even as they challenge its terms. We make a grave mistake, it seems to me, by conflating the two.

With this in mind, I will tell three stories in the following pages. All are focused on black protest within the art world. The first is an account of the disputes over the inclusion of Dana Schutz's painting *Open Casket* (2016) in the 2017 Whitney Biennial. The sec-

ond is about a 1979 exhibition at Artists Space, an independent, noncommercial art institution in New York, titled *The Nigger Drawings*. The third describes the first exhibition at the Metropolitan Museum of Art to highlight (or even acknowledge) African American life, 1969's *Harlem on My Mind*. All three were the subject of protests driven by black artists, critics, and art historians who objected not just to individual artists or works in the shows, but also to the institutions' decisions to show the works. In all three cases, the protesters recognized that what institutions hang on their walls or put on their pedestals is a clear articulation of who they imagine their audience to be. In all three cases, the protesters saw curatorial and institutional choices as clear signals that they were not part of the public that was imagined when we speak of public culture. In all three cases, the institutions believed that they were acting with the best intentions, guided by a desire to be inclusive and welcoming to an expansive and generous conception of a public. And, crucially, in all three cases, the question of who had the right to speak freely came under debate.

Instead of removing Kelley Walker's offending works from view, the Contemporary Art Museum St. Louis literally built a white wall in front of them so that passersby wouldn't have to see them unwillingly; our current administration, too, dreams of building a wall (of still-indeterminate hue) to protect against immigration and the further browning of America. The two phenomena are not unrelated, in my mind.

Hence the title for this book—*Whitewalling*—a neolo-
gism that expands in many directions: the literal site of
contention, i.e., the white walls of the gallery; the idea
of "blackballing" or excluding someone; the notion of
"whitewashing," or covering over that which we prefer
to ignore or suppress; the idea of putting a wall around
whiteness, of fencing it off, of defending it against in-
cursions. The title acts as a signpost to the assumptions
that guide the three narratives in the following pages.
In each of these stories, the protests arose from a clash
between three roughly-drawn factions: black people
and their allies who recognized that the institutions
involved were working to reinforce and center white-
ness; those who insisted, often invoking the values of
free speech, artistic freedom, civility in discourse, and
anti-censorship, that the protests themselves were the
"real" problem; and the institutions themselves, which
found themselves forced to reckon in real time with
who they are and who they are meant to serve.

 Mine is not, at root, an aesthetic argument. It is
a book about protest, and the way such protest grap-
ples with art in order to lay bare the ways in which the
art world is part of a much larger world. Supporters of
Dana Schutz, say, or of Donald, the artist who made
The Nigger Drawings—along with many "objective" art
critics—complained at the time that if protesters had
spent enough effort really analyzing the artwork they
would not object in the least; in the case of Schutz,
many dismissed out of hand any criticism from people
who had not seen the disputed painting in the flesh.

But this misrecognizes what these controversies were about. They hinged on issues much larger than any individual set of decisions an artist might make in her studio; we both give art too much credit and place an undue burden on it when we imagine that it can interrupt or overturn such pervasive systems of power as white supremacy or capitalism. What art can do, in its best and worst forms, is reveal the mechanisms by which such powers assert themselves. Art can lay bare the way that it is used as a marker of boundaries and a sign of belonging in the culture at large.

My role as a writer in these pages strays from journalist to partisan to historian to protester. I have limited myself to the textual records in some cases, forgoing interviewing the players involved in favor of taking seriously their written statements, and in others I have incorporated information gleaned from talking to people directly involved in the events. For the story of *Harlem on My Mind* I have relied on the work of scholars who have long been fascinated with what is often regarded as one of the most consequential museum controversies in US history. This bricolage approach means that each of the three acts in this book is written at a different remove, an inevitability given that the first of them occurred in the year of my birth. They are each marked, in their prose, their tone, and their point of view, by those differences in distance or proximity.

This is all to say that I am both inside and outside this account by turns, but either way fully impli-

cated. Many of the people quoted in these pages, on all sides of these three debates, are people I know—as friends, as social media acquaintances, as former teachers, as colleagues. I was an active participant in the controversy around the Whitney Biennial, too, on many fronts. I threw myself into Facebook arguments (including a scorching engagement with Coco Fusco and many others over the course of several days in March and April). I wrote about it for CNN.com. And—strangely enough—I also saw it from the "other side," so to speak, while I was working as a consultant for the Whitney Museum of American Art itself. At the invitation of Kathryn Potts, associate director and Helena Rubinstein Chair of Education at the museum, I conducted monthly readings sessions with members of the education department from October 2016 to June 2017. With me as facilitator, this group—one of the most diverse in the museum, and one that thinks deeply about whom the museum sees as its audience and how it speaks to them—grappled with questions of institutional bias, the terms and limitations of "diversity and inclusion" efforts, the ways they could challenge the racism and xenophobia happening in the world around them, and the ways those ideologies shaped, invisibly and inadvertently, what was going on in their own museum. None of us expected Trump's election, the activism and resistance that coalesced around his inauguration, or the firestorm around Schutz's painting to intervene in this ongoing work. What I learned from this interaction—about the institution and its

people, the ways in which it spoke at times with one voice and at others with multiple voices, and the transparency and opacity of institutional imperatives to those who work within them—has certainly informed my narrative. I have made the utmost effort, however, to avoid betraying the confidence of those who trusted me enough to speak freely and openly in our forums.

What follows are three stories about people's best intentions and their worst acts of bad faith, about protest and its disappearance, about a history that is not repetitive but recursive, about lessons learned and forgotten when it comes to art, race, and protest. It is, I hope, a way to begin examining what we mean when we talk about free speech, artistic freedom, censorship, racial justice, and art's value. It is the start of a conversation—a difficult conversation, to use a term that will appear often in the pages that follow—that is built on the foundation of the decades of unfinished and often ignored interventions by artists who found themselves cast in the role of protesters when they realized that the art world was making no space for them, or at least no space for them as full participants. It is written with the hope that finally, we might decide not to defer the work that remains to be done.

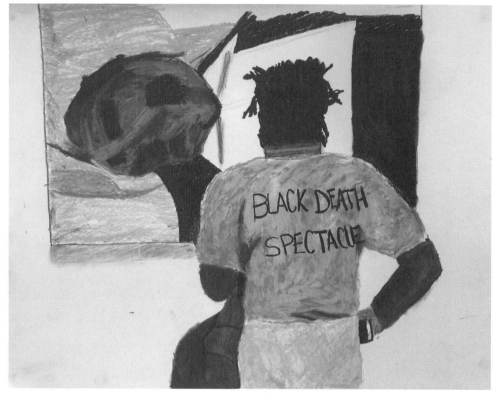

Parker Bright, *Confronting My Own Possible Death*, 2018. Mixed media on paper, 19 x 24 in. Courtesy of the artist.

ACT 1

Open Casket
Whitney Biennial, 2017

The cultural earthquake triggered by Dana Schutz's *Open Casket* (2016), a painting included in the 2017 Whitney Biennial, began as social media tremors in the days before the exhibition opened to the public on March 17.[1] Artists, critics, curators, writers, and the art-world adjacent—many but not all black, many but not all millennial and Gen Z—began expressing discomfort, anger, and disbelief that anyone thought it was okay to include *this* painting in *this* show.

 Open Casket was tucked away in a back gallery, wedged between one of the best pieces in the exhibition—Maya Stovall's video *Liquor Store Theatre* (2014–17), in which the artist and other dancers perform unannounced on the streets of Detroit and strike up

conversations with passersby—and a black-curtained door leading to a room in which was installed a multimedia video installation by Kamasi Washington. *Open Casket* was modest in scale, muted in color, and less overtly cartoonish than is typical for Schutz—out of character, that is, with the kind of work that propelled her to art-world stardom as soon as she graduated from Columbia University with an MFA in 2002.

If the aesthetic qualities of *Open Casket* felt anomalous within Schutz's oeuvre, its subject matter was also unusual. Schutz tends toward outlandish and even violent themes, rarely explicitly political or historical ones.[2] This painting, however, was based on one of the most iconic and charged photographs of the Civil Rights era—a picture of a fourteen-year-old black child, Emmett Till, in his coffin, horribly disfigured from a brutal beating that occurred when he was falsely accused of whistling at a white woman in 1955.[3] At his funeral, Till's mother, Mamie Till Mobley, insisted that his coffin be left open. She was acting in defiance of the Mississippi sheriff who only released her son's body for burial on the condition that the casket be sealed, because he wanted "to get that body in the ground so nobody else could see it," in Till Mobley's words. In a singular act of courage, she also urged that the photograph of her son's body circulate widely to "let the world see what I have seen." The picture, first published in *Jet* and other black magazines, is credited with galvanizing the Civil Rights movement and, as it circulated in the white media, with garnering sympa-

thy among white Americans who had until then paid little attention to antiracist activism. It was a crucial moment of consciousness-raising in the long struggle for desegregation and the passage of the Voting Rights Act of 1965.

In other words, the photograph was much more than an historical artifact to many people in this country. As the controversy around *Open Casket* unfolded, many commentators reiterated its significance in terms that connected the past act of violence to a lived reality of blackness. Artist, curator, and writer Aria Dean explained the visceral reaction she still has to the photograph half a century after the horrific event in a Facebook post on March 28: "Growing up and going to American private and public schools I was shown this image on more than one occasion, in a classroom surrounded by mostly white classmates. . . . As a black child with a black brother, black cousins, and so on, this image was terrifying and an explicit warning."[4] The poet Elizabeth Alexander explained that the photo inscribed a generational trauma—emboldening some, and cowing others.[5]

Perhaps, then, it is not surprising that Schutz's decision to represent this of all photos left many confused. Artist Devin Kenny, in a Facebook post from March 16, posed a series of questions that spoke to the concerns of some of those who were hearing of the painting for the first time: "what action is this work purportedly, and actually, doing? does it inform? shock? build connection? help a new audience under-

stand either emotionally or intellectually the complex set of factors all falling under the umbrella of white supremacy, sexism, and anti-blackness that led to this young person's death? if no, what element of the history is being tapped into and depicted? if not regarding the history referenced in the image, and instead about the culture of photography and its circulation, why was that particular example chosen?"[6]

Other questions inevitably followed. What did it mean for a white woman to take up this particular image, one so important to black culture and experience? Was it an act of historical witnessing or a form of cultural appropriation? What did it mean not only that the painting was made, but also that it was included in one of the most-watched art events in the US? Does the fact that an artist may be assumed to have the artistic freedom to create whatever art she wants mean that a museum is correct in showing it? Are there limits and responsibilities that go along with artistic freedom, and with curatorial judgment? And, inevitably, because this image of a brutalized black body was being shown in 2017, in the wake of a growing list of murders of young men and women of color perpetrated by the police and the officers' subsequent acquittals by judges and juries: what did this all mean now?

What started with questions around a single painting by a single artist in a single exhibition turned into a national public debate over the fundamental questions that bind culture and society: who art is

for, socially speaking; what are the responsibilities of art institutions to their audience and artists' to theirs; who is granted the right to speak and paint freely; and what censorship is and who has the power to censor.

•

Artist Parker Bright launched an opening salvo in the form of a performance, recorded in a video posted online on March 17 from inside the museum. In it, Bright is seen walking through the galleries to get to *Open Casket*. He takes off his coat to reveal a T-shirt with the words "Lynch Mob" written and crossed out with a black Sharpie on the front. He looks nervous. He awkwardly juggles the camera phone in one hand and his jacket and bag in the other. A woman off-screen eventually offers to hold the phone and continue filming so that we can see the words on the back of Bright's shirt: "Black Death Spectacle." Bright makes it to *Open Casket* and stands in front of it with arms outstretched. He then turns around and begins to chat with the museum visitors. With this single gesture, the artist both partially obscures the painting's view and adds a new, living layer to the surface of the work. In exceedingly polite terms he discusses the history of the work, posing questions to the gallery visitors about how they see the painting and what they think of the museum's decision to include it in the Biennial.

At one point, Bright points out to museumgo-ers that whatever the painting was meant to achieve,

he didn't see how it showed any particular care for black people—and states that it was not fair game for a white artist to take on a subject matter that was so rooted in black history. "I believe the painting really doesn't do anything for the black experience," Bright says to one interlocutor, pointing out that "black people really don't have access to this museum since it's twenty-two dollars to get in." Alluding both to the potential market value of the Schutz painting and the ticket price of the museum, Bright comments at another point that "no one should be making money off a black dead body." And at another: "It seems like a scheme for the Whitney to create controversy."

For two days, Bright showed up at the Whitney to conduct his protest. For a few days after that, other groups stood quietly in front of the painting in his stead. The cumulative effect of these intervening bodies was to encourage viewers to see this image of black history behind the living and breathing social reality of black lives today. The videos of these actions were viewed more than ten thousand times on social media platforms, sparking intense debate from the first moments of the Biennial.

Other protesters were likewise insistent on highlighting the connection between historical forms of racism and the present condition of black lives—and of the immediacy that the image of Emmett Till continues to hold. On March 17, artist Pastiche Lumumba hung a banner outside the museum on the High Line balcony that reproduced his own March 17

Instagram post. It read: "The white woman whose lies got Emmett Till lynched is still alive in 2017. Feel old yet?" He was approached a few minutes into his action by High Line staff, who told him to leave. The meme on which the banner was based, however, spread quickly online.

But it was the appearance of an open letter on March 21 that kicked the protests—and the backlash to them—into high gear.

It's easy to forget that the letter to the Biennial's curators penned by artist and writer Hannah Black wasn't the *start* of the protest—it was just one of many interventions and statements made as posts on social media or published in more formal venues that formed a virtual movement against *Open Casket.* Even so, it came to frame the terms of the subsequent debates and to define Hannah Black, willingly or not, as their leader—not least because of a single sentence contained therein, comprising only 31 of its 734 words: a call for the destruction of the painting.

The letter first appeared as a Facebook post on Black's page. It was not, Black later insisted, composed with any sense that it would generate the furor that eventually ensued. Rather, it was tapped out on a phone screen and circulated among friends by text message, with edits done along the way. When it was eventually posted, there were forty-seven cosignatories, including artists, writers, art critics, curators, and arts professionals; the original list included white allies, but after some discussion among the signato-

ries those names were removed.[7] Parker Bright was among those whose names were appended, although he explained to reporters later that he did it as an act of solidarity despite personally not advocating the destruction of the painting.

The statement went viral—a fact all the more extraordinary because this wasn't, after all, a meme or a news article or a cat video. It was more like an aesthetico-political manifesto, an invitation to take part in a process of truth and reconciliation, and evidence of an open wound. It generated a controversy about a *painting* that far exceeded the art world. But the thousands of people who read it and expressed an opinion—whether supportive or dismissive, whether thoughtful or knee-jerk, whether they read the whole letter or stopped after the first sentence—realized that the questions being raised were consequential. And so it's worth reading it in full, again:

> *To the curators and staff of the Whitney biennial:*
> *I am writing to ask you to remove Dana Schutz's painting "Open Casket" and with the urgent recommendation that the painting be destroyed and not entered into any market or museum.*
>
> *As you know, this painting depicts the dead body of 14-year-old Emmett Till in the open casket that his mother chose, saying, "Let the people see what I've seen." That even the disfigured corpse of a child*

was not sufficient to move the white gaze from its habitual cold calculation is evident daily and in a myriad of ways, not least the fact that this painting exists at all. In brief: the painting should not be acceptable to anyone who cares or pretends to care about Black people because it is not acceptable for a white person to transmute Black suffering into profit and fun, though the practice has been normalized for a long time.

Although Schutz's intention may be to present white shame, this shame is not correctly represented as a painting of a dead Black boy by a white artist — those non-Black artists who sincerely wish to highlight the shameful nature of white violence should first of all stop treating Black pain as raw material. The subject matter is not Schutz's; white free speech and white creative freedom have been founded on the constraint of others, and are not natural rights. The painting must go.

Emmett Till's name has circulated widely since his death. It has come to stand not only for Till himself but also for the mournability (to each other, if not to everyone) of people marked as disposable, for the weight so often given to a white woman's word above a Black child's comfort or survival, and for the injustice of anti-Black

legal systems. Through his mother's courage, Till was made available to Black people as an inspiration and warning. Non-Black people must accept that they will never embody and cannot understand this gesture: the evidence of their collective lack of understanding is that Black people go on dying at the hands of white supremacists, that Black communities go on living in desperate poverty not far from the museum where this valuable painting hangs, that Black children are still denied childhood. Even if Schutz has not been gifted with any real sensitivity to history, if Black people are telling her that the painting has caused unnecessary hurt, she and you must accept the truth of this. The painting must go.

Ongoing debates on the appropriation of Black culture by non-Black artists have highlighted the relation of these appropriations to the systematic oppression of Black communities in the US and worldwide, and, in a wider historical view, to the capitalist appropriation of the lives and bodies of Black people with which our present era began. Meanwhile, a similarly high-stakes conversation has been going on about the willingness of a largely non-Black media to share images and footage of Black people in torment and distress or

even at the moment of death, evoking deeply shameful white American traditions such as the public lynching. Although derided by many white and white-affiliated critics as trivial and naive, discussions of appropriation and representation go to the heart of the question of how we might seek to live in a reparative mode, with humility, clarity, humour and hope, given the barbaric realities of racial and gendered violence on which our lives are founded. I see no more important foundational consideration for art than this question, which otherwise dissolves into empty formalism or irony, into a pastime or a therapy.

The curators of the Whitney biennial surely agree, because they have staged a show in which Black life and anti-Black violence feature as themes, and been approvingly reviewed in major publications for doing so. Although it is possible that this inclusion means no more than that blackness is hot right now, driven into non-Black consciousness by prominent Black uprisings and struggles across the US and elsewhere, I choose to assume as much capacity for insight and sincerity in the biennial curators as I do in myself. Which is to say —— we all make terrible mistakes sometimes, but through effort the more important thing

could be how we move to make amends for them and what we learn in the process. The painting must go.

Thank you for reading.

It is impossible to say how many people laid eyes on Black's original Facebook post. At some point, she took it down, but by then, it had been reproduced countless times on social media, blogs, and art-news websites.

•

The Biennial is reliably controversial, and especially so when it comes to matters of race, gender, and representation. Since the late 1960s (when it was an annual exhibition) to today, it has been the subject of protests by artist-activists, and black artists have long referred to the museum as "the Whitey" to reflect its poor track record when it comes to including artists of color in its programming. (The Black Emergency Cultural Coalition picketed with signs saying "Is it the Whitney or the Whitey?" as early as 1971; the all-too-serious joke stuck.) Most recently, the 2014 Biennial included only nine black artists out of about 118 participants, and only about a third were women of any race. To add insult to injury, one of the few black woman artists among this paltry number was "Donelle Woolford"— the fictional alter ego of artist Joe Scanlan, who is a

white man. Scanlan's inclusion provoked a great deal of anger; the Yams Collective withdrew their work in protest of what they saw as the curators' unresponsiveness to complaints of a white artist's conceptual performance of blackface. In addition, the institution, like many of its kind, has long been criticized for the fact that any diversity that might exist among its staff is not reflected where it really counts—in its curatorial departments or upper administration. With its move from the Upper East Side to its new building in the Meatpacking District, the Whitney was also vulnerable to charges that it was taking part in a process of gentrification that was pushing long-standing communities of color (as well as low-income residents, LGBTQ teens and elders, and immigrants) out of the neighborhood.

The museum was hardly unaware of or unconcerned by this history. Since the move, Adam Weinberg, the Whitney's director, has made clear his commitment to working toward a more diverse and inclusive institution. The 2017 Biennial seemed designed to further this goal. The museum appointed two Asian Americans as cocurators of the exhibition—Christopher Y. Lew, a member of the Whitney's own staff, and Mia Locks, an independent curator—marking the first time the Biennial would be led by a curatorial team composed entirely of people of color. Lew and Locks would go on to put together what many observers would recognize as the most diverse Whitney Biennial to date: there were over thirty artists of color

and over thirty women of all races included among the sixty-three artists and groups in the show—an extraordinary statistic, one that comes close to actual US demographics.

It was also, as many art critics noted in the almost unanimously glowing reviews that appeared in the days before it opened to the public, the most outspokenly "political" Biennial in some time. Lew and Locks were more than a little conscious of their moment in history, as they made clear in interviews preceding the opening of the show. After a presidential campaign marked by extreme misogyny and overt white supremacist rhetoric leading to the election of Donald Trump, at a time of increasing numbers of anti-immigrant and xenophobic crimes, and in the shadow of the highly publicized police murders of black men and women that fueled the rise of Black Lives Matter and other antiracist activist groups, the stakes were high. In the press release announcing the names of the participating artists, Lew and Locks highlighted this context. "Throughout our research and travel we've been moved by the impassioned discussions we had about recent tumult in society, politics, and the economic system. It's been unavoidable as we met with artists, fellow curators, writers, and other cultural producers across the United States and beyond," Lew said in the statement. Locks continued: "Against this backdrop, many of the participating artists are asking probing questions about the self and the social, and where these intersect. How do we

think and live through these lenses? How and where do they fall short?"[8]

But while the Biennial may have been outspoken in many ways, when the controversy around *Open Casket* erupted, the Whitney's response was initially tight-lipped. Lew and Locks, as is usual for the Biennial's curators, functioned in a semiautonomous fashion, supported by the museum but not "part" of the museum. As such, they ended up being the main spokespeople on the controversy by default, though Locks was not even on staff. It was only on March 21— the day they met with Bright and Black's letter was posted online and went viral—that the two released a short statement to the press. They upheld the value of the debates surrounding *Open Casket*, intimating that the exhibition was designed precisely to provoke such reactions while condemning unequivocally the call for the destruction of the painting in Black's letter. "By exhibiting the painting," wrote Lew and Locks, "we wanted to acknowledge the importance of this extremely consequential and solemn image in American and African American history and the history of race relations in this country. As curators of this exhibition we believe in providing a museum platform for artists to explore these critical issues."

This call to grapple with critical issues and have important conversations when it comes to art is one that is familiar to anyone with even a glancing experience of the art world. Curators and museums bring it up when questioned about their decision to show

certain works of art, no matter who is asking that question—whether it's a rabble-rousing conservative politician objecting on the grounds of a narrow and self-serving "morality," or members of a disenfranchised group protesting what they see as bias, or simply average visitors who don't understand what they happen to be looking at. Museums by and large see themselves as serving the public interest by providing the platform for such debates. So it is perhaps not surprising that as soon as the controversy began, staff at the Whitney began to discuss how to respond to the outcry—how to "own" the controversy, in some sense. For Megan Heuer, the director of public programs, that meant creating an event that would shift the debates from the anarchic space of social media to the museum, thus making them part of the show's public record, and demonstrating that the Whitney could be an appropriate site to contend with the issues raised by Schutz's decision to make the painting, or even the curators' decision to include it.

But as the curators had made clear from the start, removing, let alone destroying, the artwork was out of the question, which posed a dilemma: would hosting a conversation under these terms not simply result in leveraging protesters' words to burnish the reputation of the museum itself—demonstrating the museum's graciousness and open-mindedness at the same time as occluding its refusal to act on the protesters' demands? The need to respond quickly to a protest gaining speed on social media was also an is-

sue. As Heuer reflected in a recent conversation, "Although the museum had to respond to, and was focused on, the public outcry over the painting, there was a parallel conversation happening inside the Whitney as well. Everyone in the museum had to grapple with *Open Casket* and we were all metabolizing the protests differently."

On March 30, the museum announced that it would invite the poet Claudia Rankine's Racial Imaginary Institute to host a conversation on "Perspectives on Race and Representation." Rankine, winner of a 2016 MacArthur "genius" award, had used her prize money to establish a think tank that at its outset was devoted to the study of whiteness. The collaboration made sense: not only did the issues raised by the protests fit perfectly with the Racial Imaginary Institute's mission, but it would allow for an "independent" assessment of the controversy, one not limited by the museum's terms. Fourteen speakers, chosen by Rankine's group and the Biennial curators, were asked to make short presentations, with audience questions at the midway mark and at the end. Black and Bright were both invited, but chose not to participate. Other protesters also declined to appear largely because the museum was standing firm in its refusal to remove the painting from view. Schutz did not attend either, though she was asked. In the end, this may have bolstered the Whitney's hopes that they could broaden the conversation so as not to center the work of a single white woman in a Biennial that included so many

people of color.

On the evening of April 9, Weinberg introduced the event. Significantly, this was the first public statement he had made about the protests. Weinberg reiterated his desire for the museum to be a platform for debate and public discourse. "I am here to listen," he said, before joining the audience for the rest of the evening.

But listen to what, exactly? What seemed to hang over the program—perhaps taking the museum by surprise, given the protesters' ostensible focus on Schutz's painting up to that point—were questions of what we are talking about when we talk about art, and what makes art meaningful. For many onlookers, what was at stake was not simply *Open Casket*, but its entire framing. Weinberg's and the Whitney's decision to listen respectfully was interpreted by some in the audience (both in the room and watching online) not as a laudable determination to focus on the art itself and the historical and political issues it raised, but as a refusal to allow the institution itself—its allocation of resources, its structural biases, its decision-making processes and management, and its power as cultural arbiter—to come into question. For those streaming the event online and holding "viewing parties" on Facebook, including the artists Caitlin Cherry and Tomashi Jackson, the event fell short. It seemed too stage-managed, for one, leading some to interpret it as a public-relations move rather than a genuine conversation. "It was frustrating that the Whitney pretend-

ed it was a neutral moderator in the event when the only reason the event happened was because of their mistake that caused a need for a response about *Open Casket*," recalls Cherry.

To the legendary performance artist Lorraine O'Grady, whose work has long engaged the issue of museums' racial exclusiveness, the Whitney's silence on the question of their institutional complicity was not news. To have a discussion about race and representation in 2017 without acknowledging the Whitney's failure to change its institutional direction after the lessons of two of its own race-focused exhibitions in the 1990s—the 1993 Biennial curated by Elisabeth Sussman, excoriated by the press for its insistent multiculturalism, and Thelma Golden's equally vilified 1994 exhibition *Black Male*—was, to O'Grady, intellectually dishonest. She stood up and spoke from the audience in the first question period, setting the tone for much of what followed:

> We cannot get away from the fact that we are sitting in a space, the Whitney Museum, which is hosting a Biennial and a panel about the Biennial. This whole discussion has to be framed within the institutional context that we are sitting in. And the question is, since the 1993 "multicultural" Biennial and the 1994 *Black Male* show, that is but a quarter of a century for the administration and the structure

of the museum itself to consider these issues and to begin to address them. The entire question of this show as far as I'm concerned is, indeed, why was the Whitney not prepared for what the eventuality of this Biennial would produce? Why has the Whitney not increased the curatorial staff of color in twenty-five years? We can discuss a great deal about lynching and its significance in the racial imaginary and all of that. But we are here in a very specific context, and the specific context is that of the museum and its intellectual discourse. We need to hold the Whitney accountable for its lack of probity, for its lack of preparation and for its lack of material advancement of these issues that it's been facing now for twenty-five years, a quarter of a century.

It was Lew—not Weinberg—who responded to this comment. He reiterated the museum's commitment to grappling with issues of race and representation. But his next words provoked murmurings in the audience: he posited that his presence on the curatorial staff at the Whitney was evidence that Golden's curatorial interventions in the early 1990s had had their effect. Even on the archived video, you can see the temperature in the room drop as he speaks at this point—there was visible shock at Lew's positing his

own appointment as a solution to the problems that O'Grady was highlighting in her forceful remarks.

Lew was mistaking, perhaps understandably, what was at stake for the protesters: reading their outcry as a plea for *diversity* at the museum, as opposed to an insistence that the museum face its own structural *antiblackness* and its complicity in centering whiteness. Lew's presence on staff as a nonblack person of color was not, in fact, a guarantee that the institution's antiblackness would be recognized or addressed, as the playwright Young Jean Lee insisted in her intervention during the second question period. Lee pointed to the ways in which antiblackness played out even in Asian American communities, and insisted, too, on attending to differences in how anti-Asian racism and antiblack racism play out in American culture. Rather than assume a privileged knowledge of the racism that the Schutz painting disinterred, she insisted that Asian Americans should on the contrary be listening. She then extended the apology to African Americans that in her mind the Whitney should have already given. "I'm sorry," she repeated, over the course of her comments.

The tensions in the room came to a head in the final moments of the event, when Rankine thanked the audience and the Whitney for coming together to take "a first step" in thinking through the difficult questions that the Schutz painting coalesced. She expressed, among other things, gratitude that the museum was responding exactly as it should, by opening

itself up to public discourse. At this point, the artist Lyle Ashton Harris, who had been one of the evening's speakers and whose work appeared in the Biennial, jumped up from his seat and grabbed the microphone, and in an impassioned voice insisted that the examination of whiteness wasn't something new—black artists have been examining whiteness for decades—and if the Whitney hadn't figured that out yet, it wasn't because they didn't have the information, but because they were actively ignoring the issue to disastrous effect. "I don't want to have a 'kumbaya' moment," he boomed. The audience roared in approval.

•

Though Schutz did not take part in the April 9 event, she had attempted to speak several times over the course of a few weeks about her decision to make *Open Casket*.[9] In a statement put out on March 21, and posted as part of a revised wall label in the gallery on March 28, she said the painting had been conceived in August 2016, "after a long, violent summer of mass shootings, rallies filled with hate speech, and an ever-escalating number of Black men being shot execution style by police, recorded with camera phones as witness." She began thinking about Emmett Till, another young black man, the victim of another form of state-sanctioned violence—lynching.

"I don't know what it is like to be Black in America," her statement continued. "But I do know what it

is like to be a mother. Emmett was Mamie Till's only son. I thought about the possibility of painting it only after listening to interviews with her. In her sorrow and rage she wanted her son's death not just to be her pain but America's pain." In a March 23 interview posted on Artnet, she acknowledged, "The anger surrounding this painting is real and I understand that. It's a problematic painting and I knew that getting into it. I do think that it is better to try to engage something extremely uncomfortable, maybe impossible, and fail, than to not respond at all."[10]

These explanations did not sit well with many of the protesters. One of the main arguments against *Open Casket* was that Schutz's decision to paint the Till photograph was an act of cultural appropriation: "The subject matter is not Schutz's," in Black's pithy terms. Bright had said in his Facebook video something similar: "I feel like [Schutz] doesn't have the privilege to speak for black people as a whole or for Emmett Till's family." The charge was repeated, in various forms, in hundreds of Facebook and Instagram posts, and argued vociferously online.

The question of when, and on what terms, a person is justified in taking up the cultural forms and historical legacies of groups (races, ethnicities, genders, etc.) to which they themselves are not a part is always fraught, but especially so in the art world where cultural "borrowings" are the cornerstone of the European avant-garde tradition we've been taught to admire. To declare certain subject matters off-limits for

artists was—for many of those who pushed back on the protesters' objections—fundamentally opposed to artistic freedom. What made the accusation worse in this case were echoes of essentialism that many heard in the protesters' cries: the idea that one's identity is innate, and so white people should only be doing "white art," black people "black art," and so on, or that certain subject matters are only available to certain people depending on how they are racialized.

The clash between these two ideas—cultural appropriation on the one hand, and antiessentialist insistence on uninhibited artistic freedom on the other—led to unexpected mappings of positions in the debates. The controversy did not play out as a starkly black versus white issue; on the contrary, at times it seemed that the divide was more generational than racial. This was especially true for black artists and writers who had come of age in the 1980s and 1990s, a generation or two older than many of the protesters. Those belonging to this older generation had worked hard to reject both the legacy of the Black Arts Movement of the 1960s and 1970s, with its messy search for a "black aesthetic" and insistence that the primary value of black art was its relevance to the struggles of the black community, and the tokenization of artists of color by writers and curators in search of multicultural diversity who valued them mainly for their ability to speak to issues of race and perform a kind of race-based "authenticity."

During the Schutz controversy, many of the

same black artists, art historians, writers, and critics who had resisted being boxed into limiting notions of identity twenty-five years ago firmly rejected the idea that there were some subject matters that were off-limits to white artists on the basis of their identity. Among them was Kara Walker. Walker had been subject to protests in the early 1990s by an older generation of *black* artists—including Howardena Pindell and Betye Saar—for using racist antebellum imagery and stereotypes in her silhouetted wall works. When the Schutz controversy boiled over, Walker put up a series of public Instagram posts that referred obliquely to the younger artist's predicament. The first, on March 23, consisted of an image of Artemisia Gentileschi's iconic painting *Judith Beheading Holofernes*, and referred to the fact that "the history of painting is full of graphic violence and narratives that don't necessarily belong to the artist's own life, or perhaps, when we are feeling generous we can ascribe the artist some human feeling, some empathy toward her subject."[11] Another, on April 9, featured a photo of her cat, and outlined the history of protests against her work, which hinged on the "critique of the reach and power of the black image in art as well as who has the authority/authenticity to address race."[12]

Performance artist and theorist Coco Fusco also responded to the protests, penning an article that appeared in the online art publication Hyperallergic on March 27. Fusco's article was read widely—garnering well over 150,000 page views and over twenty-five

thousand shares on Facebook alone—and for many was considered the last word on the subject. Fusco aligned the protests against Schutz with "a deeply puritanical and anti-intellectual strain in American culture that expresses itself by putting moral judgment before aesthetic understanding." She went on to "analyze [Black's] arguments, rather than giving them credence by recirculating them, as the press does; smugly deflecting them, as museum personnel is trained to do; or remaining silent about them, as many black arts professionals continue to do in order to avoid ruffling feathers or sullying themselves with cultural nationalist politics."[13] Among Fusco's many contentions are that "[Black] relies on problematic notions of cultural property and imputes malicious intent in a totalizing manner to cultural producers and consumers on the basis of race" and "presumes an ability to speak for all black people that smacks of a cultural nationalism." Citing a long history of abolitionist and pro–Civil Rights images by white artists, Fusco insisted "the argument that any attempt by a white cultural producer to engage with racism via the expression of black pain is inherently unacceptable forecloses the effort to achieve interracial cooperation, mutual understanding, or universal anti-racist consciousness."

There was a great deal of pushback from younger black artists, writers, and their supporters. Thom Donovan, a poet and curator, summed up these objections succinctly in a Facebook post of March 28.[14] He took issue with Fusco's dismissal of the Black Arts

Movement, which, he said, has been "important to younger Black artists and Artists of Color, especially given the prominent and specious uses of terms like 'post-Black' in contemporary art discourse." He also rejected the idea that the abolitionist empathy of the white artists about whom Fusco wrote approvingly led to politically sound art: "I agree [with Fusco] that Schutz's painting evokes white abolitionist empathy (i.e. identification with and projection upon black suffering/death), and that such aesthetic amusements are contiguous with abolitionist cultural production (*Uncle Tom's Cabin* to present)," he argued, his "agreement" ironically making apparent that he placed less value than Fusco on the efficacy of *Uncle Tom's Cabin* as an antiracist tract.

•

Although Fusco never used the word *empathy* in her article, her argument did hinge on the idea of empathetic allyship—that by policing the boundaries of who could address particular histories of racism, the protesters were rejecting a long tradition of antiracist, abolitionist, and pro–Civil Rights art and literature by white people. In this, she was very much in tune with the bulk of Schutz's supporters.

At the heart of the discussions about Schutz's choice to paint Emmett Till was the question of empathy. Her defenders considered her attempt to deal with this particular death as not just appropriate, but

necessary. "In her sorrow and rage [Mamie Till Mobley] wanted her son's death not just to be her pain but America's pain," Schutz wrote, echoing the feelings of so many people—white people, for the most part—who were trying to understand, in the wake of a long-overdue attention to the history of racial injustice in the US, how to heal these festering wounds. Art was a way to enact such healing, said Schutz: "Art can be a space for empathy, a vehicle for connection. I don't believe that people can ever really know what it is like to be someone else (I will never know the fear that black parents may have) but neither are we all completely unknowable."

In the aftermath of the 2016 presidential election, liberal pundits realized with horror how many people were willing to vote for an outspoken white supremacist, a misogynistic, homophobic, transphobic, ableist, and otherwise hateful man, and doubled down on the idea that empathy was the key to a more progressive political arena. "Love trumps hate" became the postelection rallying cry, as it had been during Hillary Clinton's campaign: a slogan that placed the personal obligation to understand each other at the heart of a politics of resistance. In this context, Schutz's desire to see Emmett Till's death as part of an unhyphenated *American* history was very much part of the work that many white Americans decided they must start to do in order to tackle the continuing and enduring racism of their country.

In their response to the outrage, the Biennial's

curators concurred: "For us it was so much about an issue that extends across race," said Lew in the *New York Times.* "Yes, it's mostly black men who are being killed, but in a larger sense this is an American problem." Locks added that the painting was a way of "not letting Till's death be forgotten, as Mamie, his mother, so wanted."[15]

Even before the controversy erupted, the curatorial framing of the Biennial reflected such attitudes. As Locks said in the exhibition catalogue, one of the motivations of the show was to bring into visibility new forms of solidarity that were forming across lines of race and other oppressions—in other words, questions of how to be allies:

> Thankfully, we're seeing more and more public conversations about race and structural asymmetries. These issues have been taken up by Black Lives Matter in very significant ways. It's not always been the case in American history, or art history for that matter, that we've talked about these conditions in a direct way. This is happening right now, and it feels necessary to declare this as a moment—to think not just about race but about systemic racism, and how the various power structures that are in place are enmeshed. And I would add that a pet peeve of mine is when people assume that

artists of color or women artists or those whose identities are more marked would be the only ones to address these issues. *In our show, questions of inequity and asymmetry are driven by artists thinking across lines, developing ideas about allyship and coalition politics that go beyond the limited frameworks of the past.*[16]

In this context, it was all but inevitable that Schutz's painting would become a flashpoint. While many on the left faced the results of November's election with an anguished reckoning, there were others, especially black women, who were—not to put too fine a point on it—fed up: once again disappointed at the ways in which white liberal politics, especially white liberal feminism, had failed them. The feeling came from the terrifying fact that 53 percent of white women had voted for Trump. It came from seeing that for all the soul-searching being done by many of the other 47 percent about the role racism played in his victory, very few were willing to examine their own investments in whiteness and white supremacy. It came from watching white women publicly speak the language of intersectional feminism in Facebook posts, but lashing out at anyone asking them what they were doing to improve the lives of black women in any tangible way. It came from endless occasions of being scolded by white progressives, who counseled that now, in the face of Trump's threat, it was important to

put aside "identity politics" in favor of uniting behind a common cause—one that often overlooked the radically different effects such a threat might have when it comes to class, race, and so on. It came from hearing that if we would only pay attention to the overlooked needs of the white working class, instead of the needs of the 96 percent of black women who voted against Trump—an almost identical list of needs, it should be noted—we wouldn't be in this mess. It came from the fact that so many of the people who were supposed to be allies had failed to step up, or had imagined that simply being sad and empathetic (or at least performing their empathy) was enough.

Indeed, for those who spoke up against Schutz's painting, the question was not whether she, as a white person, was free to engage the subject matter at all—but whether she had done so ethically and responsibly. The difference is articulated in words leading up to Black's seemingly blanket proscription against the possibility of white artists taking up Emmett Till's death: "Although Schutz's intention may be to present white shame, this shame is not correctly represented as a painting of a dead Black boy by a white artist—those non-Black artists who sincerely wish to highlight the shameful nature of white violence should first of all stop treating Black pain as raw material. The subject matter is not Schutz's." In other words, the issue is not that Schutz cannot engage with a particular history in her art. Rather, it's that in her position as a nonblack person, her artistic choices failed to rise to the level of

historical and political understanding needed to meet the work's own social and artistic ambitions. She may have wanted to stand in solidarity. Instead, she acted as a bad ally.

Perhaps Schutz made the same mistake that all those people chanting "love trumps hate" were making: assuming that the mere personal performance of empathy could be enough to bridge the kind of gap she wanted to address. "I don't know what it is like to be Black in America, but I do know what it is like to be a mother," she wrote. Where Schutz's supporters heard in her words a brave attempt at empathy, her detractors heard her centering herself and her feelings—her white tears, as some would derisively describe it—at the expense of black viewers for whom Emmett Till was anything but historical. In this vein, Aria Dean, one of the signatories of Black's open letter, wrote the following in a Facebook post of March 21 (subsequently published in the New Inquiry):

> I am not a mother myself, so I may be speaking out of turn, but it is my understanding and my sense based on the experiences of my mother and my grandmothers and all of the black women who have mothered children or helped to nurture any black child at any stage of life, and my feeling as someone with even the vaguest potentiality of black motherhood (and furthermore black parents in

general, fuck the invocation of mother-hood to some degree, black fatherhood is plagued with these same worries) that the degree to which the murder of your child is incomprehensible to a white mother exists on a plane very distant from the way that possibility exists in the mind of a black mother. For the black mother, the possibility of violence and death for her black child is a reality, not a conceptual impossibility that might by horrific, unimaginable accident find its way to her doorstep.[17]

Later in the same post she presents the issue in even starker terms: "To equate white motherhood, black motherhood, and the fear that runs through each of them is violent and nothing else."

While Schutz may have imagined that she was channeling black pain in her work—the pain of Till Mobley and all the black mothers, before and since, who had to witness the violence visited on their loved ones—her artistic gesture was inevitably read through another lens: that of white lies. At the end of January 2017, not two months before the Biennial opened, *The Blood of Emmett Till*, a book by Timothy B. Tyson, revealed what many already suspected: that Carolyn Bryant Donham, on whose accusations the murder was carried out, had lied.

In this context, Schutz's claim that she seized

on the image of Emmett Till as a way to process the spate of recent murders of black youth sounded to many like a way of sidestepping her own relationship to the historical processes that resulted in these deaths. Schutz made *Open Casket* from an aesthetic and social vantage point that left a glaring blind spot: the complicity of whiteness, and of white womanhood, in those events. By placing herself in Till Mobley's shoes instead of Bryant Donham's, Schutz crucially avoided—self-servingly, in the protesters' eyes—the pressing and timely question of how so much "justice" in this country (vigilante or otherwise) was and still is justified by the need to protect white women from black and brown men. (It is no accident that Trump's xenophobic presidential campaign started with his characterization of Mexican immigrants as criminals, as drug dealers, and, above all, as rapists.) Schutz's artistic choice made *Open Casket* at best a missed opportunity to actually understand what Emmett Till's death means for white America, and at worst a narcissistic act as positioning herself as a victim—just like that other mother, Till Mobley—of American racism.[18] As Josephine Livingstone and Lovia Gyarkye put it in a March 22 article in the New Republic:

> Emmett Till died because a white woman lied about their brief interaction. He died because his side of the story did not mean anything to the two white men who killed him, just as it meant nothing to the jury

that acquitted them. For a white woman to paint Emmett Till's mutilated face communicates not only a tone-deafness toward the history of his murder, but an ignorance of the history of white women's speech in that murder—the way it cancelled out Till's own expression, with lethal effect.[19]

Lumumba summed up many of these issues in a widely shared post on Facebook on March 21:

Dana Schutz's painting depicts the violence inflicted on black people but says nothing about who has been inflicting it. The problem here is that when white people think about racism they think only about what happened to its victims and not its perpetrators, because they are the perpetrators and it's so much easier to simply display the pain of others than examine their own complicity within it. Dana did the former which is not only lazy, shallow, and uncritical but is ontologically linked to the tradition of white people reveling in the spectacle of Black death. . . . If white people can only talk about racism from the perspective of its effect on black people then they will not be able to dismantle

their own complicity and will continue to enact their racist behavior. This is not constructive for anyone.[20]

On the website The Root, Michael Harriot further undermined the accusation that those who questioned Schutz's decision to paint *Open Casket* were guilty of essentialism by turning the concept of whiteness from an adjective to a verb. Schutz's crime was not that she was white, he explained, it's that she was "white-peopleing"—centering whiteness and white pain in her response to black death:

> There is sure to be some pushback over artistic freedom, the right to free speech, and whether the entire subject and history of America's discrimination against people of color should be off-limits to white artists. But this controversy isn't about rights or freedom. This painting is a prime example of peak white-peopleing.
>
> What is "white-peopleing"?
>
> White-peopleing is the privilege and dismissive confidence that you have not only the right but also the permission to do whatever the fuck you want. White-peopleing is the audacity of believing that

your white hands are gifted with the skill, soul and empathy to transmute the horrific spilling of black blood into something passersby can contemplate before they move on to another sculpture or painting. It is either not knowing or disregarding the difference between a mother saying, "Look what these monsters did to my boy" and a New York paint-slinger saying, "Look what I did." White-people-ing is this.

•

Harriot was surely guilty of understatement when he wrote that there would be "some pushback over artistic freedom, the right to free speech, and whether the entire subject and history of America's discrimination against people of color should be off-limits to white artists." In fact, at moments it felt like these were the only questions most of Schutz's staunchest defenders wanted to address—often to the exclusion of other, equally trenchant issues.

Some were less surprised than others about how the protest was dominated by free-speech arguments. As scholar Christina Sharpe reminded those in the audience at the Rankine-organized conversation at the Whitney on April 9, in a statement read out in her absence, white supremacy always sucked moments of black protest back into its terms, "and so the argu-

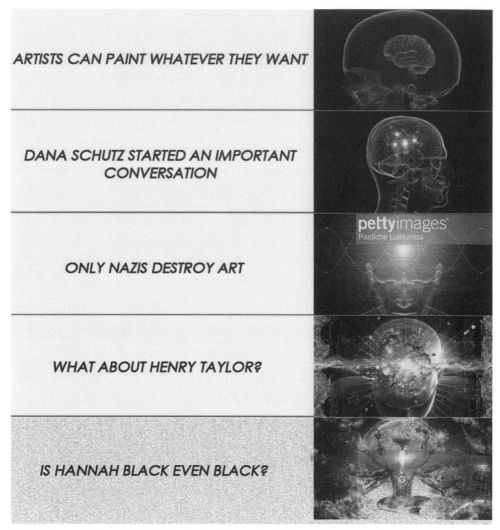

Pastiche Lumumba, *Expanding Brain Dana Schutz Open Casket*, 2017. Meme. Courtesy of the artist.

ment over representation, circulation, violence and consumption gets knotted up, bogged down, and derailed over the question of censorship. Polemic is not censorship."[21] And indeed, it hardly mattered whether the people weighing in on the controversy were calling for the painting's destruction, asking for it to be removed but not destroyed, or even just questioning the inclusion of the work by the Biennial's curators—as often as not, they were *all* branded as censors. In the adrenaline-filled discourse of Facebook, it was simply the impulse to question the circumstances around Schutz's painting that made the protesters no better than the man currently occupying the White House, who rails against freedom of the press to assuage his thin skin and cover his corruption; no better than Nazis and book burners; no better than the Christian Right, with their puritanical objections to contemporary art; and, most importantly, no better than the Republican lawmakers who tried to shut down the National Endowment for the Arts in the 1990s for sponsoring "obscenity."[22]

The controversy over *Open Casket* may have seemed like a traumatic repetition of those early 1990s instances of censorship to Fusco and others of that generation. But there was a crucial difference. Now the attacks on artistic freedom were coming not from the US government, but, for the most part, from young black artists, critics, curators, and writers—individuals who, in the scheme of things, are rarely afforded

institutional powers or privileges, let alone the power of the state. At the Racial Imaginary Institute's April 9 event, the artist Malik Gaines expressed incredulity that Black's call for destruction was being collapsed into this other, darker history: "Can't we tell the difference between a gesture by an artist that's rooted in a black critical negativity and the violent instruments of racist state regimes?" He went on to talk about the generative role destruction has played in art practice in the twentieth and twenty-first centuries. At the same event, Ajay Kurian, an artist whose work was also featured in the Biennial, offered the following statement, read out in absentia:

> The call for the destruction of this work of art is not as troubling as the depth of institutional misery and death inflicted daily on people of color, and more specifically on Black Americans. If you believe Hannah Black's letter is somehow the catalyst towards a more fascist world, if this is the signal that has caused you fear, consternation, or altogether rethinking of the openness of the art world, then your ass has already swallowed your head. This does not mean I condone the destruction of the work, as much as I am suspicious of the moral outrage, the judgmental tone, and the hateful speech surrounding the

publishing of Black's letter. Dana Schutz
has not been censored.

Sometimes the anticensorship arguments were
put in the harshest terms—no subject matter or speech
act should be off-limits, and to suggest otherwise
makes you a Nazi book-burning Trump supporter. At
other moments, they were framed in terms of diversi-
ty and the need to make our platforms for discussion
as open as possible in order to move our culture in a
better direction. In a December 15 article on the pro-
tests against artworks in 2017, the *Los Angeles Times'*
art critic Carolina A. Miranda worried that the debate
over whether artworks should be removed—just the
debate, mind you—"threatens to constrain artists at
a time when a multiplicity of voices and subjects is
what's needed."[23]

The "multiplicity of voices and subjects" is what
the Whitney hoped to achieve in its diversity-driven
2017 Biennial, too. It is a goal that sounds like an in-
arguable good—why force certain speech acts off the
stage when you can simply invite all speakers onto the
stage? But, of course, the Whitney, no matter its own
aspirations, is neither neutral nor infinitely large—a
Biennial is by necessity carefully curated, meaning
that certain voices have already been excluded. When
the protesters were demanding that the Schutz paint-
ing must go, they were not suppressing Schutz's right
to speak—they were challenging the curatorial deci-
sions that gave her a platform, while denying others

the same opportunity. And they were asking that the museum recognize its power to do so.

•

The accusations of censorship and other vitriol directed toward the protesters speaking out against *Open Casket* proved what many of them had long suspected: that freedom of speech, far from being a universal liberal value, was one that only white people can take full advantage of. Black had alluded to it in the open letter: "The subject matter is not Schutz's; white free speech and white creative freedom have been founded on the constraint of others, and are not natural rights." In this short sentence, the open letter lays bare the ways in which values that we claim are universal and available to everyone are in fact doled out unequally depending on how we are raced.

I often wonder what would have happened had Black's letter not begun with an incendiary call for the work's destruction. Would the thousands of people from all corners of culture who weighed in on the controversy—from art-world insiders to those who have never stepped into a museum to Whoopi Goldberg on *The View*—have been able to hear what was being said in the rest of the letter? Would they have seen the call for the artist and curators to acknowledge their mistakes as an opportunity to enter into a reparative form of justice, of truth and reconciliation, whereby

the inequities that underpin the art world can begin to shift? And, just as important, would they have been able to see the charge of cultural appropriation not as Fusco and others did—as censorial essentialism—but for what it was: a materialist argument, a struggle over resources?

As many of the protesters made clear in their posts and comments about the affair, cultural appropriation was not only about identity, but about how economic and cultural resources are available to some, while others—artists who share a cultural and historical link with Emmett Till, who grew up hearing his story as a warning and a call to action—are left without. From this point of view, the fact that Schutz made explicit that she would never sell the work or allow it to enter any museum collection didn't mean much. The problem with her work was the way it traded on not only a cultural but also a *"capitalist* appropriation of the lives and bodies of Black people with which our present era began," as Black put it in her letter (emphasis mine). Protesters like Black saw in Schutz's painting both a question of who may or may not speak to black history and one of how those acts of speech are exploited in capitalism. Black's repeated declarations that "the painting must go" were a demand that *all* black bodies be taken out of circulation as commodities. The open letter encourages the idea that Schutz's work be seen in the context of the real black bodies that were brutalized for profit in the past (under slavery) and in the present (e.g., through the

prison industrial complex), and of the myriad ways that images of such violence were circulated to police blackness. By this reasoning, there was no other solution than that the painting be destroyed.

As is often the case when it comes to acts of protest in the US—think of the pearl-clutching over looting and broken windows during the Ferguson uprising, an anxiety that seemed in some quarters to far outweigh concern over the actual murder of a black man or the violent suppression of demonstrations by the police—it was the attack on a valued commodity that provoked most of the backlash. In a sense, the open letter was designed to create such a reaction by putting the call for the painting's destruction out front, laying bare once again the way that liberal culture seems consistently to value things over people.

But here is where the conversation broke down: for the protesters, the question was always about people. It was never about things.

NOTES

1 Much of the early debate was triggered by an Instagram post of March 16, 2017, by the influential critic Jerry Saltz, who posted a photo of *Open Casket* with a comment about how beautiful it was; a number of vocal commenters took great issue with appending the descriptor *beautiful* on an image of a black corpse. The post, and the subsequent comment thread, has been heavily edited in the meantime. Jerry Saltz, "Here

is a repost of my 2017 Whitney Biennial review," Instagram, March 16, 2017, https://www.instagram.com/p/BRs0lkX-lG1s/?hl=en&taken-by=jerrysaltz.

2 One exception to this rule was her 2006 painting *Poisoned Man*, an image of Viktor Yushchenko, the Ukrainian political leader widely thought to have been dosed with dioxins by the Russian government. For a useful discussion of the problems with Schutz's approach to her subject, see Dushko Petrovich, "The State of Painting," *n+1*, June 17, 2015, https://nplusonemag.com/online-only/online-only/state-painting/.

3 Maurice Berger, in a piece for the *New York Times*' Lens blog, provides an excellent history of the photographs and their resonance today: Maurice Berger, "The Lasting Power of Emmett Till's Image," *New York Times*, April 5, 2017, https://lens.blogs.nytimes.com/2017/04/05/controversy-contexts-using-emmett-tills-image/.

4 The Facebook post was reprinted in the New Inquiry on the same day. Aria Dean, "The Demand Remains," New Inquiry, March 28, 2017, https://thenewinquiry.com/the-demand-remains/.

5 Racial Imaginary Institute, April 9, 2017.

6 Devin Kenny, "I don't want to see depictions/interpretations of Black trauma made by those with no proximity to that experience," Facebook, March 16, 2017, https://www.facebook.com/devinkk/posts/658751390060.

7 The other signatories of the letter were Amal Alhaag, Andrea Arrubla, Hannah Assebe, Thea Ballard, Anwar Batte, Parker Bright, Harry Burke, Gaby Cepeda, Vivian Crockett, Jareh Das, Jesse Darling, Aria Dean, Kimberly Drew, Chrissy Etienne, Hamishi Farah, Ja'Tovia Gary, Hannah Gregory, Jack Gross, Rose-Anne Gush, Mostafa Heddaya, Juliana Huxtable, Alexander Iadarola, Anisa Jackson, Hannah Catherine Jones, Devin Kenny, Dana Kopel, Carolyn Lazard, Taylor Le-Melle, Beatrice Loft Schulz, Jacqueline Mabey, Mia Matthias, Tiona Nekkia McClodden, Sandra Mujinga, Lulu Nunn,

Precious Okoyomon, Emmanuel Olunkwa, Mathew Parkin, Temra Pavlovi, Imani Robinson, Andrew Ross, Cory Scozzari, Christina Sharpe, Misu Simbiatu, Addie Wagenknecht, Dominique White, Kandis Williams, and Robert Wilson.

8 Whitney Museum, "2017 Whitney Biennial, the First to Take Place in the Museum's Downtown Building, to Open March 17," press release, November 17, 2016, http://press.whitney. org/file_columns/0012/9984/2017_biennial_artist_list_pr._ with_image.pdf.

9 Her statement was first circulated to the press on March 21 and appeared in the form of a revised wall label for the painting on March 28. The quotations here are taken both from the wall label and from Randy Kennedy, "White Artist's Painting of Emmett Till at Whitney Biennial Draws Protests," *New York Times*, March 21, 2017, https://www.nytimes. com/2017/03/21/arts/design/painting-of-emmett-till-at-whit-ney-biennial-draws-protests.html.

10 Brian Boucher, "Dana Schutz Responds to the Uproar Over Her Emmett Till Painting at the Whitney Biennial," Artnet, March 23, 2017, https://news.artnet.com/art-world/dana-schutz-responds-to-the-uproar-over-her-emmett-till-paint-ing-900674.

11 Kara Walker, "The history of painting is full of graphic violence," Instagram, March 23, 2017, https://www.instagram. com/p/BR-3iH5l0ZW/?taken-by=kara_walker_official.

12 Kara Walker, "Pearl is revisiting Vol. 14 no. 3 issue of the International Review of African American Art 'Stereotypes Subverted or for Sale?' and 'Kara Walker Yes/No?,'" Instagram, April 9, 2017, https://www.instagram.com/p/BSrs9N-HlKj4/?taken-by=kara_walker_official.

13 Coco Fusco, "Censorship, Not the Painting, Must Go: On Dana Schutz's Image of Emmett Till," Hyperallergic, March 27, 2017, https://hyperallergic.com/368290/censor-ship-not-the-painting-must-go-on-dana-schutzs-image-of-emmett-till/.

14 Thom Donovan, "I am suspicious of the call to "reason" and the dismissal of the values of an affective response to the painting," Facebook, March 28, 2017, https://www.facebook.com/thom.donovan.1/posts/10210109652552437.

15 Randy Kennedy, "White Artist's Painting of Emmett Till at Whitney Biennial Draws Protests," *New York Times*, March 21, 2017, https://www.nytimes.com/2017/03/21/arts/design/painting-of-emmett-till-at-whitney-biennial-draws-protests.html.

16 Scott Rothkopf, "Sincerely Yours: A Conversation with Christopher Y. Lew and Mia Locks," *Whitney Biennial* 2017 (New York and London: Whitney Museum of American Art and Yale University Press, 2017), p. 24. My emphasis.

17 Aria Dean, "The Demand Remains," New Inquiry, March 28, 2017, https://thenewinquiry.com/the-demand-remains/.

18 An index of the ways in which Schutz was being seen as a "bad ally" is supplied by a letter that was published in the Huffington Post and other publications on the morning of March 23. Claiming to be a statement by Schutz herself, the letter asked the Biennial curators to take down the work. "I am writing to publicly request that my painting, 'Open Casket,' be removed from this year's Whitney Biennial. Though it was not at all my intention to cause harm, many artists have come forward to announce that my depiction of suffering is in turn causing them suffering. I cannot rightly protect a painting at the expense of human beings." The letter goes on, in the language of nonviolent communication familiar to social-justice activism, to "acknowledge" Schutz's failure to act in solidarity with the black folks whose pain Open Casket was meant to depict: "I understand that many have attempted to defend my work in the interest of free speech, and with calls against censorship. However, the artists and writers generously critiquing 'Open Casket' have made plain to me that I have benefited from the very systems of racism I aimed to critique, in a way that blinded me to what my re-presenting this image would mean to Black audiences." As

soon as the letter was posted, social media seemed to breath a sigh of relief, and even her staunchest supporters celebrated her decision. Within an hour, however, the Whitney put out a statement that the letter was fake, and the Huffington Post retracted it. See Benjamin Sutton, 'In Fake Letter, "Dana Schutz" Demands Removal of Controversial Painting from Whitney Biennial,' Hyperallergic, March 23, 2017, https://hyperallergic.com/367347/in-fake-letter-dana-schutz-demands-removal-of-controversial-painting-from-whitney-biennial/.

19 Josephine Livingstone and Lovia Gyarkye, "The Case Against Dana Schutz," *New Republic*, March 22, 2017, https://newrepublic.com/article/141506/case-dana-schutz.

20 Pastiche Lumumba, "So this is what the curators had to say about that painting at the Whitney. Let's break this down. Dana Schutz's painting depicts the violence inflicted on black people but says nothing about who has been inflicting it," Facebook, March 21, 2017, https://www.facebook.com/photo.php?fbid=10154521916696089&set=a.10150588733446089.380590.505711088&type=3&theater.

21 "Perspectives on Race and Representation: An Evening With the Racial Imaginary Institute," Whitney Museum of American Art, accessed February 23, 2018, https://whitney.org/WatchAndListen/1493.

22 That this reaction was a demonization of protest in and of itself was not perhaps surprising in the current climate; in early December 2017, when a petition with seven thousand signatures was delivered to the Metropolitan Museum of Art asking curators to rethink their hanging of Bathus's pedophiliac painting *Thérèse Dreaming* (1938), its goals were modest: "I am not asking for this painting to be censored, destroyed or never seen again. I am asking The Met to seriously consider the implications of hanging particular pieces of art on their walls, and to be more conscientious in how they contextualize those pieces to the masses. This can be

accomplished by either removing the piece from that particular gallery, or providing more context in the painting's description. For example, a line as brief as, 'some viewers find this piece offensive or disturbing, given Balthus' artistic infatuation with young girls.'" Despite this, the *New York Post* and scores of social media commenters excoriated the exceedingly reasonable petitioners as unreasonable censors, as hair-triggered snowflakes.

23 Carolina A. Miranda, "In 2017, an Angry Public Demanded the Removal of Controversial Art Works. Could the Debate Limit Artistic Freedom?," *Los Angeles Times*, December 15, 2017, http://www.latimes.com/entertainment/arts/miranda/la-et-cam-year-end-miranda-art-came-down-20171214-story.html.

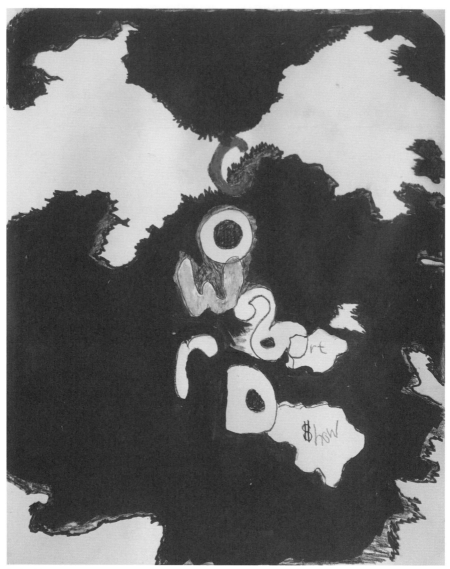

Parker Bright, *Coward$*, 2018. Mixed media on paper, 24 x 19 in. Courtesy of the artist.

ACT 2

The Nigger Drawings
Artists Space, 1979

At the April 9 event that dealt with the controversy around *Open Casket*, Mia Locks, one of the 2017 Whitney Biennial curators, addressed the protesters directly. "I want to start by acknowledging the perspectives that you have shared, and just to say that I appreciate much of what you've said and written," she said. She went on to discuss the logic behind hanging Schutz's painting in proximity to Maya Stovall's *Liquor Store Theatre*, Harold Mendez's makeshift monuments, and the other pieces in the room; she talked, too, about its relationship to a work on another floor, Henry Taylor's depiction of the murder of Philando Castile at the hands of a police officer. She then posed a series of questions raised by the juxtaposition of these pieces,

including what black feminism might have to say about the visualization of black bodies in relation to violence, what these artworks do that's different from simply documenting racist crimes, and what other kinds of thinking these works encourage.

She herself did not suggest any answers to these questions, and instead highlighted the ways in which the act of curating was to generate moments of what she called "uncertainty." "Uncertainty," she said, "is important, it has merit."

For Locks, as for many curators, the goal of curating is to put works together in order for them to "generate conversation." Uncertainty—ambiguity, open-endedness, even dissension—is itself a curatorial value. It is something to leave a space for, at the least, when deciding what to hang on the walls, or even to seek out; this is what curators mean when they speak of putting works in conversation with each other.

But what are the limits of this curatorial value? The protesters were, explicitly and implicitly, posing this question to the Whitney by asking whether all works were worthy of being uncertain about. After his meeting with Locks and her cocurator Christopher Lew on March 21, Parker Bright said in a video statement, "One thing that the curators told me is that they were encouraging that type of conversation, that sort of response, which I'm kind of conflicted about because I'm not sure the proper way to have this conversation is to throw black dead bodies in people's faces, but that's just the way it is at this point."

And then, too, there was the matter of whether the conversation provoked by the installation of *Open Casket* in the Biennial was one that the Whitney was prepared to have. The museum and the curators seemed willing to examine America's racist history, the politics of empathy, and notions of political allyship, but it had demurred from wading into other quagmires opened up by the protests, including that of the Whitney's own responsibility and complicity with structures of white supremacy and antiblackness in culture at large.

There is a contradiction at the heart of our idea of open dialogue: while it seems to depend on clearing space for ambiguity, uncertainty, and the contingent, it is grounded in—and perhaps even depends on—de facto limits of who can speak and what can be said. This contradiction was revealed fully by the protests centered on a 1979 exhibition at Artists Space, a scrappy and vital independent art institution in New York City, then located on the edge of a newly redeveloped (some might say gentrified) arts district in the former industrial wasteland of SoHo.[1] It ran from February 19 to March 10, and was one of four exhibitions at the Hudson Street venue. Along with Dennis Adams's text-and-image piece focused on Patricia Hearst, James Casebere's para-autobiographical black-and-white photos, and Barbara Levy's still lifes and street scenes, the press release announced, in a breathtakingly understated way, the following:

> Donald's "Nigger Drawings" are seven 5'
> x 7' triptychs combining black and white

photography and charcoal drawing. This series of work was made between 1976 and 1978. The artist is currently engaged in making a series of larger color works.

The controversy started when one person took notice of something others had inexplicably overlooked. In this case it was an artist named Janet Henry. In addition to her studio practice, Henry was an active participant in Just Above Midtown gallery, Jamaica Art Mobilization, the Studio Museum, the Jamaica Arts Center, the Exhibitionists cooperative gallery, and other black art spaces that were springing up in New York City, established largely by black artists and curators who felt shut out of "mainstream alternative" venues like Artists Space.

For whatever reason, the advance announcement of *The Nigger Drawings* did not draw Henry's attention, and seemingly didn't make much of an impression on others, either. It's not entirely clear why that should have been the case. Later on, some of those who would eventually lead the protests, including Lowery Stokes Sims, an influential curator at the Metropolitan Museum, and Howardena Pindell, at the time a curator at MoMA and an artist involved in activist circles, claimed that they had been deliberately left off the mailing list for this one show, a claim that Artists Space director Helene Winer vehemently denied in letters to Pindell and Sims.

In any case, it took Henry noticing the announce-

ment, wandering into the gallery, seeing the show, and speaking to the staff—including Cindy Sherman, who had recently moved to the city from Buffalo to pursue her photography career and was working as a receptionist there—to set off alarms.

The New York alternative art scene was a relatively small world at the time, and many of its participants were friends and acquaintances as well as colleagues—Pindell and Winer, for example, had a long and affectionate friendship, and Henry was acquainted with a number of staff members at Artists Space, too. While some might imagine that these bonds would have mitigated the vitriol that would follow in the coming months, I imagine that they just fueled the fire—so much of the language that surrounded the event, on the parts of both the protesters and counter-protesters, was that of betrayal, as we will see.

Henry has described the experience of realizing what her acquaintances at Artists Space had done as a punch in the gut. She was rendered literally speechless and fled immediately to Just Above Midtown gallery, run by Linda Goode Bryant, to calm down and relate what she had seen, thereby setting into motion a protest that would last long after the exhibition closed.

She wrote a letter on March 6 to Jim Reinish, a program associate in charge of visual arts for the New York State Council on the Arts, one of the major funding sources of Artists Space (along with the National Endowment for the Arts). Henry took pains to point out her response was not that of a woman "triggered,"

or reacting purely out of emotion. It was, on the contrary, that of someone who had given a great deal of consideration to what she was looking at:

> Giving everybody the benefit of the doubt
> I went to the show. I wanted to see how
> Donald (the aforementioned artist) visualized the word *and to confirm my assumption that a black male was actually being shown at Artists Space.* [Emphasis mine.]

I love this sentence in Henry's letter, which jibes so completely with my own encounters with racism—you always begin by assuming that you must be mistaken, that there is a reasonable explanation, because why would anyone want to act in a hurtful way? Also, her subtle jab: even more surprising to Henry than a white artist using such a word would be an exhibition by a black artist at Artists Space.

Henry goes on:

> As I stated previously, Donald isn't black
> and wasn't when he did the drawings.

Note the slyness here: it seems designed to counter the inevitable argument, common in that postmodern moment, that race (or other matters of identity) shouldn't be treated in an "essentialist" way—i.e., as something innate in a body—but instead be understood as a set of experiences, performances, and iden-

tifications. However one chooses to define blackness, Donald never fit the bill, Henry suggests. Okay, back to the letter:

> His explanation (as related to me by the receptionist) for choosing "The Nigger Drawings" as the title of his show was due to the intense involvement he developed with the charcoal. Alright, then why not Black Drawings? Charcoal is black, uncomplicated, straightforward BLACK. The word Nigger is neither. Even with extensive social exposure and extensive scholastic research, Donald could never begin to understand the numerous meanings and applications of the word.

In other words: there may be a case to be made that a white artist could use the N-word in some sort of critical, antiracist way, but that's not what's happening here. The problem for Henry was not a categorical one. Donald's casual use of one of the most explosive and violent terms in American English, the ham-handedness of his justification as telegraphed via the Artists Space employees, and the fact that it seemed to have been given the blessing of Artists Space, was read by Henry as a supremely hostile gesture: "[It] is saying to these groups that no matter how good you get, no matter how much you are needed, you ain't what we are and therefore will never drink from the same

fountain we do. You will also put up with anything we choose to sling in your face." She calls it like she sees it: "Seems like somebody's asking for a fight."

•

A fight was, indeed, the result. The protest gained steam quickly, thanks to Goode Bryant, Pindell, and a number of other artists and critics, both black and white, who called themselves the "Emergency Coalition." These included people who had already established themselves as foundational figures in the alternative art world: the Minimalist sculptor Carl Andre (who would, some years later, stand trial for the murder of his wife, the Cuban feminist performance artist Ana Mendieta); the feminist critic and curator Lucy Lippard; the artists May Stevens and Tony Whitfield; Cliff Joseph, cochair of the Black Emergency Cultural Coalition, and Faith Ringgold, one of the founding members of the group; and Ingrid Sischy, who was named editor of *Artforum* that year and would go on to be a major force in the publishing world. On March 5, they, along with five other signatories, sent a one-paragraph open letter to Artists Space, objecting to the decision to mount the exhibition: "We assume [the title] was chosen as some sort of puerile bid for notoriety," they wrote, "but we are amazed that the staff of Artists' Space has lent itself to such a racist gesture. Surely it must have occurred to you, if not to [the artist], that this was an incredible slap in the face of Black and

other artists, of Black audiences and of everyone connected in any way with one of our leading alternative spaces. Did anyone object to these antics, or is social awareness at such a low ebb in the art world that nobody noticed?"

Underlining the tone of incredulity, on the bottom of the copy of the letter sent to Artists Space director Helene Winer is a handwritten note from her friend and occasional collaborator, Lippard: "Helene—Sorry about this but *how* could it have gotten by?! Lucy."

The coalition's letter was also sent to Reinish at NYSCA; within days, he received separate letters from Pindell, Sims, and (as we've seen) Henry. All three noted their objection to federal and state funds being used to support, as Pindell put it, the use of a racial slur "under the guise of aesthetic freedom." (Pindell and Henry, it should be noted, were both former members of the advisory panel for the visual arts program at NYSCA.) A few days later, art historian Carol Duncan wrote, "Are those of us who pay taxes in New York State supposed to think that this is clever? Art-world chic? Mr. Reinish, racism is racism. In elegant quarters like the art world, it usually works covertly. . . . We know it's there, but on this occasion we get our noses rubbed in it, and by a state-funded institution! An insult on top of an injury. I would like to see more responsible use of public funds."

NYSCA didn't waste time expressing their discontent. They sent a telegram to Winer on the very day the open letter was released. (Looking back at the

correspondence around this exhibition shows just how quickly this issue caught fire—it was a preinternet and pre–social media form of virality, itself an extraordinary reminder of the urgency surrounding the event.) "We would like to express the council's distress at the poor taste used in such a choice of titles," the telegram stated. "We believe art should bring people together and not be divisive as such as title [sic] becomes, particularly since it is unrelated to the content of the work."

And what was the "content of the work," exactly? Pindell and Henry both pointed out in their letters of objection that neither the artist nor the gallery had provided any explanation for the use of the title, beyond the very basic answer that the one-named Donald was fascinated with charcoal. (Even this explanation of the artist's "fascination" with charcoal was a euphemism: Sherman had told Henry, when asked about the title, that at the end of his drawing sessions Donald's arms were covered with black pigment, making him look like a "nigger," in his mind.) With this paltry information, how was there any way to interpret his gesture as a considered artistic choice rather than a juvenile attempt to shock? Certainly, as Sischy pointed out in her letter to Reinish a week later, a more satisfying connection than "charcoal equals black equals nigger" wasn't at all apparent:

> When I was told about an exhibition by a
> Donald at Artists Space entitled "Nigger

Drawings" I gagged but I groped. I said
he must be black. No. Then I said it must
be what the work's concerns are. . . . No.
Then I said the work must be punk. No.
The work is as formal and as academic as
can be. And good too. . . . I kept groping
for a relationship, for a reason. Nothing.

Donald didn't help matters. The twenty-three-
year-old California native (whose full name, Donald
Newman, would only circulate publicly sometime lat-
er) had studied with John Baldessari at CalArts and
moved to New York in 1975 to participate in the Whit-
ney Independent Study Program. Armed with a rec-
ommendation from Baldessari, he apparently ingra-
tiated himself with Winer, who let him crash in the
gallery on his first night in the city; within a few years
of his arrival Winer gave him this, his first solo show.[2]

His rawness was perhaps one explanation for
the ham-handedness of his interventions. He put out
a number of statements over the course of the contro-
versy—which lasted far past the exhibition's closing
date of March 10—and agreed to a number of inter-
views, but his positions only fanned the flames. In all
of these he insisted on identifying himself only with
his first name, a choice the art critic Roberta Smith
(who otherwise admired the work) would later char-
acterize as "obtrusive," and which even Winer, in pri-
vate conversations, believed was "silly."[3] On March 8,
Donald wrote a letter to the Emergency Coalition in

which he claimed to be the progeny of artists like D. H. Lawrence, Henry Miller, William S. Burroughs, and other cultural disruptors—and declared that as a boundary-pushing artist, he was more or less obligated to transgress and abuse the artistic freedoms granted to him in order to transform culture.

Donald also alluded to a complex and nuanced interaction between the inflammatory word and the work—insisting that one could not understand his use of the word outside its interaction with the drawings themselves. However, he declined to draw out this formal connection.

> What one finds implicit in the title is the question of the word's relationship to the work as a whole, and that work's relationship to the use of the word in our society. These questions should be answered before charges of racism etc. are leveled at any work of art, particularly when levelled not at its overall intent but when levelled impetuously and blindly against a single phrase or word.

Noting at the end of the letter that Lippard had not seen the work in question—and that he hoped that the rest of the Emergency Coalition "are not guilty of the same negligence and over enthusiasm"—Donald placed the onus on them to discover what he believed to be the case: that the titling of the series wasn't rac-

ist, and that he did not have any further responsibility to contextualize it himself.

Indeed, Donald may not have felt an urgent need to explain his choices—being a young artist in New York in 1979 might have seemed to him explanation enough. Jeff Chang, in his 2014 book *Who We Be: A Cultural History of Race in Post-Civil Rights America*, discusses *The Nigger Drawings* specifically in terms of the punk scene, a milieu marked by an amoral drive to destruction, transgression, and a rejection of the trappings of bourgeois culture, especially its pieties around gender, race, and sexuality. To change the world meant to redefine language, to neutralize it, to disarm it by embracing its ugliest aspects. In statements Donald made during the course of the fiasco, it is clear that he saw himself as part of this movement: in a March 17 communication, for example, he referred to Patti Smith's recent song *Rock N Roll Nigger* and declared that, like Smith's album, his title was meant to contribute to an ongoing "de-racialization" of the word. Winer herself would pick up this argument over the course of the debates: "At this point, nigger is a broadly used adjective that no longer simply refers to blacks in a pejorative context. Artists refer to the projects gallery at the Whitney as the 'nigger gallery' because it ain't the big time upstairs. People are neutralizing language. These words don't have quite the power they used to—and that seems like a healthy thing."[4]

The prospect of losing favor with NYSCA was

no small matter, however: the organization provided 60 percent of Artists Space's annual funding, to the tune of $74,000 per year. (In today's terms, this amounts to over a quarter of a million dollars; by contrast, the three top-funded art organizations focusing on people of color received only around $18,500 per year *combined* from NYSCA.[5]) Winer and her team knew they had to respond. Immediately upon receipt of the NYSCA telegram they removed the title from the gallery wall, and closed the space for a day. On March 10—the last day of the exhibition—Artists Space put out a statement "to apologize for the offence caused by the title of a recent exhibition." It was sent to all the original signatories of the protest letter along with members of the Artists Space board.

The statement is extraordinary in that it reflects clearly that Winer and her staff were caught entirely unawares by the passion of the objections: "It was not anticipated nor intended that the use of an acknowledged provocative term in this situation would be interpreted as a racist gesture." The statement explained that in this case, as with other exhibitions, Artists Space had merely followed its usual practice of "commit[ing] to the artist and his work" and "respect[ing] his right to present his work unedited." It conceded, "We made an error in assuming that this word could be legitimately used in an art context," and went on to note that "it appears that to many its use is categorically unacceptable."

Also noteworthy: the statement did not make

the least attempt to defend the artwork itself. In fact, it did not even mention Donald by name.

•

The apology was too little, too late. Pindell saw it as evidence that Winer—by focusing on the hurt feelings of an offended few—still did not grasp the underlying issue, which was the structural reasons that allowed the offense to occur. She raised the stakes accordingly. In a letter to Winer, copied to Kitty Carlisle Hart (the former starlet and socialite who now chaired NYSCA), Pindell wrote: "In nothing that you have said or done have you shown any understanding. Apology means nothing when it is done to save face or save your job. I personally question you and your staff continuing to be employed there." Duncan, too, insisted that Winer had missed the point: "Sponsoring 'The Nigger Drawings' was not simply a lapse of 'good taste'. . . . Nor is it simply an isolated case of 'insensitivity' or mistaken judgment that hurt the feelings of a few friends, as you suggest. Your statement asks that we put this incident aside as a unique 'case' and continue business as usual." Henry concurred: in a handwritten letter to Rags Watkins, the associate director of Artists Space, she wrote, "I wish I could say that an apology was enough but I can't. You have to understand that 'The Nigger Drawings' show was a symptom of a disease & that the malady won't disappear until something is done about it."

What is the "disease" Henry was referring to? Alan Wallach, a Marxist art historian from Kean College of New Jersey, made clear in his March 19 letter to Reinish that it was much larger than the art world:

> Since the mid-1960s, despite gains made by the civil rights movement and the growth of a black middle class, real income for blacks has fallen. . . . Government figures show unemployment among black youths at 40%; the actual figure may be over 50%. . . . The decline of the civil rights movement in the 1970s has been accompanied by a resurgence of both covert and explicit racism. In the related worlds of entertainment, fashion and art, Aunt Jemima is a camp collector's item, whites thrill to black entertainers who 'ain't misbehaving,' fashion pages show expensively dressed white women served by liveried blacks, the new wing of the National Gallery exhibits no black art while in its elegant dining room black waitresses in maids' outfits wait on an almost all-white clientele.

Like Wallach, Duncan (another committed Marxist) suggested that Winer "consider the funding of an exhibition called 'The Nigger Drawings' in relation to what you read in the newspapers." The

economic downturn of the 1970s had led to an at-
mosphere in which black health and well-being were
"dispensable," Duncan argued. But she also insisted
that the event exposed the way in which the aesthetic
language that so many relied on to justify their curato-
rial, critical, and aesthetic choices was meant to rein-
force white supremacy, though in the most polite, lib-
eral terms. Noting that the culture industry operates
to serve bourgeois interests, Duncan pointed out that
the notion of curatorial "neutrality" that Artists Space
used to defend its decision—that it refused to censor
Donald's show because it was not in the business of
censorship—was a con:

> This doctrine of aesthetic neutrality pre-
> tends that your judgments have no social
> or moral implications. With an ideology
> like that, you don't have to be a conscious
> racist: your esthetic beliefs do the work
> for you, letting you accept responsibility
> only for artistic quality—by definition,
> neutral. . . .
>
> You certainly did make a professional
> mistake. You failed to enforce racism ac-
> cording to the usual, silent, polite meth-
> ods. You let the racism become overt and
> exposed the social practice that your 'es-
> thetic' position is supposed to mask. You
> failed to draw the line at the point where

you could still get away with the myth of neutrality. You let everyone see that your art gallery—and by extension, other high art spaces—is anything but a neutral or alternate space.

In this context, the fact that Artists Space approved Donald's title was at best, as Henry put it, a symptom—and at worst, per Wallach, "an art world trial balloon." "The art world has had very little room for non-white artists and almost no room at all for a non-white audience," Wallach wrote. "'The Nigger Drawings' suggest something even more sinister. The message to the ghetto is 'let them eat cake.' The message to the art world is racism equals fashion and 'good taste.'"

•

As quickly as the letters of condemnation had poured in to NYSCA (and would continue to pour in over the next weeks and months), so too appeared letters of support. Their defenses of Artists Space varied. Some felt the protesters were just creating a distraction borne from a place of privilege. Mark Segal, assistant curator of film and video at the Whitney, wrote that "it is so easy to attack the use of a word or a name from the comfort of a secure niche within the art world, much easier than attacking the more complex inequities regarding race, sex, and privilege which permeate

the very core of that world, and the society at large."
Even the directors of Fashion Moda, an alternative,
POC-focused space in the Bronx that depended on
funding from the Committee for the Visual Arts—Art-
ists Space's de facto board of directors that regranted
funds to other organizations—were impatient with the
protesters' objection to the use of the word, calling it
a "pre-historic position and a waste of valuable energy
that could be used dealing with the real issues that face
minority artists." This trope—why are you distracting
yourself with this brouhaha when the *real* problems
are "over there"—is strikingly pernicious, and charac-
terizes most Facebook debates, especially among the
left, in the age of Trump.

Much ink was spilled in the protests and coun-
terprotests on the meaning of the word itself, and on
language's capacity to change under social pressure—
or not. And the arguments mounted were in some
cases highly theoretical. This was, after all, the post-
modern moment: one in which artists and critics were
attuned to the ways in which all forms of representa-
tion were constructed, and could, by turn, be decon
structed. While for Goode Bryant the word recalled
"the stench of southern jails, cocked guns, dog bites
and the ever present red-screaming cries" of her expe-
rience of the segregated South, there were an extraor-
dinary number of (mostly white) counterprotesters
who insisted, simplemindedly, that it was just a word.
And that even if it was a racist word, the artwork itself
wasn't racist, so the *use* of the word wasn't racist. And

that even if the racist word was used in a racist way, that fact doesn't justify censorship, even in the form of "passive" censorship (choosing not to show work that may offend).

Art critic Roberta Smith made a "what's good for the goose is good for the gander" argument, although in slightly more sophisticated language, when she wrote, "Certain opponents of the work's title have objected to its use by a 'white artist' in reference to 'abstractions'—these were the phrases in the first open letter to Artists Space by the then-unnamed Emergency Coalition—suggesting that it might have been all right for a black artist to have used it for a nonabstract work. It's peculiar to declare a word off-limits, and even more peculiar to declare it off-limits to some people and some work and not others." (It is hard to miss the repetition of this very argument in the defenses of Dana Schutz's *Open Casket.*) The artist Dennis Adams, whose exhibition at Artists Space ran concurrently with Donald's, claimed that to insist on a fixed, negative reading of the word *nigger* contradicted the very nature of Donald's art, which rejected "a single level of reading"—presumably because it combined media (photography, drawing) and used the additive method of collage.

Douglas Crimp, then the managing editor of *October* magazine and curator of one of the most significant shows to have appeared at Artists Space (the watershed *Pictures* exhibition, in 1977), also focused on the notion of aesthetic complexity, one very much

rooted in the structuralist and poststructuralist dis-
courses embraced by *October.* In a March 16 letter
to Carlisle Hart, NYSCA's chair, and Robert May-
er, its director, he dismissed any claim that Donald
was merely courting notoriety, for "whatever notoriety
[he] has gained reflects upon him only negatively, and
one can hardly imagine a serious artist wanting that."
Rather, Donald's choice of title was the sign of the
work's value as art:

> [It] has been the lesson of an entire cen-
> tury of aesthetic endeavor that both lan-
> guage and imagery function at a level of
> ambiguity that must suspend the imputa-
> tion of an absolute and specific meaning
> to *any word, any picture.* It is, of course,
> the context of words and images that
> determines their meaning, and I would
> like to ask the protestors in this case to
> explain in what way Newman's drawings
> might provide their title with the context
> that could be construed as racist, or in
> any other way offensive.

This is a deeply formalist argument. It sees the
artwork as a closed system of signification not depen-
dent on a larger social context for its meaning—per-
haps not surprising, given Crimp's scholarly and criti-
cal bona fides. Crimp is saying, in effect, that whatever
meaning the N-word might have outside the specif-

ic interaction of image and text that makes up Donald's artwork is irrelevant—and, like Donald, places the onus on the protesters to explain how, within that feedback loop, the word can be considered racist.

Crimp expanded this argument in a short statement in *Artworkers News* some time later, explaining that the protesters were, in fact, asking those who knew anything about how art functioned to take an unsupportable leap into illogic:

> Anyone involved with the interpretation of works of art quickly learns one thing: that this is a discourse that does not admit of [*sic*] verifiability. One can make a persuasive argument about interpretation, but one can never prove it unconditionally. And that is perhaps why so many people have been so incredulous that a small group called the Emergency Coalition takes Donald Newman's title . . . as a clear cut, unambiguous instance of racism. They seem to be telling us that we must suspend everything we know about how art and language function, and in this case accept it as simply *true* that any use of the word "nigger" is categorically racist.

For Crimp, the very fact of the ambiguity of the title—the complexity, in other words, of the relationship be-

tween word and image, and a notion of language that was untethered from any fixed meaning, only gaining significance from its relation to other signs—was evidence that the word *nigger* was *not* being used in a racist way in Donald's drawings. But Crimp et al.'s claim that Donald's drawings represented a laudable open-endedness or even disruption of fixed definitions was understood by the protesters as a disingenuous smoke screen, a way to use seemingly unimpeachable artistic values (who on earth would want to defend limiting an artwork's meaning?) to "normalize" not just the word but the whole racist history it represented. The lack of any real intelligibility behind the juxtaposition of *that* word and *those* images was read as not just ambiguous but arbitrary—as casual, unmotivated, thoughtless, and even flippant. For the protesters, the word could not so easily shed its long, violent history—and if it were possible, it certainly would not be thanks to Donald's visual interventions, which Sischy described as anything but subversive—they were "as formal and academic as could be," she said.

But it was not simply the protesters' "unsophisticated" understanding of how language worked that constituted their attack on artistic freedom, according to Artists Space's supporters. It was the method of their protest itself. By writing to NYSCA directly instead of to Winer and her staff, the angry mobs were threatening Artists Space's very existence. As Crimp had written in his own letter to Carlisle Hart: "That artists, critics, and other professionals should attempt

to censor an organization for what they conceive to be its irresponsibility by addressing themselves to a government funding agency instigates, in my estimation, a politically dangerous situation." Indeed, he goes on to explain, to protest in a way that might jeopardize Artists Space's funding—and thereby its very future—would put creators at the mercy of the commercial art world, and lead to the further privatization of culture.

Dennis Oppenheim, who served on the Committee for the Visual Arts and who himself had inspired criticism for speaking in a "black voice" and adopting black street jargon in *Spinning a Yarn* (1975), compared the protesters' strategy to "a child tattling to a parent over a squabble." (Another member of the Committee for the Visual Arts, Vito Acconci, had also flouted the taboo against the N-word in his piece for the 1977 Whitney Biennial, *Tonight We Escape from New York*, featuring an audio track in which Acconci can be heard to say, "I'm talking to you, how else could I talk to you, down, down, we made you nigger, you're a nigger, damn, damn, higher, higher, you cunt . . .")

The Conceptual photographer Louise Lawler went a step further than Crimp and Oppenheim, insisting that the protesters should not have complained to the funding bodies *or* to Winer, but should have addressed themselves directly to the artist and to the public: "Their objections were to what they believed to be a racist use of a racist term, presented to the public by Artists Space. Would they not have been more effective and more supportive of this public if they had

raised the issue with the people who came in contact with this work rather than attempt to jeopardize the existence of a situation where a worthwhile discussion among artists and the public has been established?" The question of how the protesters were meant to approach an artist who had only been identified to them as "Donald" throughout the course of the exhibition, or how to engage directly with the Artists Space audience—or, indeed, why it should have been the protesters' responsibility to educate the public on this issue, rather than Artists Space's or the artist's—was left unanswered by Lawler.

Around this time another open letter was issued, signed by Rosalind Krauss (cofounder of *October* and an influential art historian and critic), Roberta Smith (the art critic, now at the *New York Times*), Laurie Anderson (the iconic performance artist), Craig Owens (an art critic associated with *October* who would go on to become an editor at *Art in America*), Crimp, and Stephen Koch (an art world–adjacent author), among others. It claimed the protesters had not misjudged their strategy at all, but rather had cynically used the nonissue of racism to further their underlying, nefarious agenda—to shut down Artists Space entirely. "While we condemn racism and its persistence in the art community," the statement read, "we believe that no racism is involved in this instance, but rather that this sensitive issue is being exploited by the Emergency Coalition, as a means of attracting attention. We deplore their attempts to use government funding

agencies as organs of censorship, their prolonged harassment of an extremely valuable and ethical arts organization, and their insensitivity to the complexities of both esthetics and politics."

Owens, in a brutal opinion piece published in the April 1979 issue of *Skyline*, suggested that Winer's only crime was that she "overestimated the sophistication of her audience." He also reiterated the charges that the protesters' methods were *in and of themselves* a form of censorship because they "attempt to use the governmental agency as an instrument of repression." Owens then went on, in a breathtakingly bald fashion, to double down on Donald's attempt to "de-racialize" the offending term: "Because of the nature of their work," he concluded, "the artists who show at Artists Space and avail themselves of its services have . . . been denied access to the commercial gallery and museum power structure. In this sense, they are all 'niggers.'" In a letter to the editor the next month, magazine editor Judith Aminoff praised Owens's "incisive and smart editorial," giving "thanks from all of us 'niggers' in the blighted world of CULTUREBURG."

Reading these letters and articles in their entirety, one comes away with the impression that the mostly white defenders of Artists Space saw themselves as an embattled minority—in this case, in relation to the big-money commercial art world—and in doing so painted an even more embattled minority

(black artists, writers, audiences) as the ones wielding the real power.

●

In many of the defenses of Artists Space and in the pearl-clutching over the protesters' lack of decorum-*cum*-bad politics, Pindell was often cited as the main culprit, over and above the white protesters, including Andre, Lippard, and even the unapologetically outspoken Duncan, not to mention the people, white and black, who were present at the meetings, teach-ins, and demonstrations that occurred around the controversy. When Winer complained to writer Richard Goldstein about his essay in the *Village Voice*, in which he accused Donald, Artists Space, and the "artistic freedom above all" faction of falling for the "romance of racism," she singled out Pindell as the "dogged" orchestrator of the letter-writing campaign and faulted Goldstein for not naming her as the culprit in his article. Crimp, in his statement in *Artworkers News*, complained of Pindell's "insidious," censorial strategy of keeping "the New York State Council on the Arts, the National Endowments for the Arts, the Press, and various individuals apprised of the minutest details of this controversy." The painter Donald Sultan, who had his first solo show at Artists Space a few years before, sent Pindell a scolding, even vaguely threatening letter (copied to NYSCA and the NEA). In the short diatribe, he referred to her "anger" twice

and her "outrage" once, and implied that she was ethically out of bounds for protesting this show because of her "position at the museum" (New York's Museum of Modern Art). He goes on to define the role of a curator to her—mansplaining at its most heavy-handed. These sorts of attacks on Pindell—whom Henry described as the protesters' "entrée" into the workings of the art world because of her education, connections, and position at the leading modern art museum in the country—may well have had their intended effect: Pindell reported that in the wake of the controversy she felt increasingly ostracized at MoMA, and eventually stepped down from her post as result.[6]

In an especially troubling document—a personal letter from Lippard to Winer dated March 28, 1979—we start to see how thoroughly the reactions to the protest might have been wrapped up in a fear of black anger, and specifically of black women's anger. Lippard, who was in the embarrassing position of curating an upcoming show at Artists Space while being at the same time one of the signatories of the open letter, apologizes to Winer about how things have developed. She explains her role in the campaign as a kind of calming influence, as an attempt to cut off such anger at the pass: "I co-wrote the open letter . . . because I was only in town for 2 days and felt that if it were written fast and that if an apology from Artists Space came through fast and hard, tempers would not have time to escalate. . . . Alas, they did have time and the artist's [Donald's] belligerent attitude hardly helped. I

must say I've come to feel that it's just as well, though, to have the art world forced to think again about the fact that it is part of the real world—all that Ingrid's [Sischy] and Carol Duncan's and Alan Wallach's letters, among others, said so brilliantly." All three of the brilliant spokespeople she cited were white, and in fact the only time she mentions black artists at all is when she refers to the cosigners of the open letter of March 5 as "just the people we ran into and the few Black artists who didn't want to write their own letters."

The tone of this letter rankles the contemporary ear; we might say today that this letter demonstrates the way in which Lippard was acting in the role of a problematic ally—performing her antiracism publicly while also working (consciously or not) to maintain the privileges of whiteness. Both Lippard and another of the open letter's signatories, May Stevens, were active participants in second-wave debates over feminism's racial exclusiveness in their work with the Heresies Collective, a feminist group that published an influential journal in New York.[7] As the Artists Space controversy was unfolding, Heresies was being taken to task by the Combahee River Collective, a queer, Marxist, black feminist organization whose membership included Audre Lorde, for its almost exclusive focus on whiteness. For many black artists and art-world participants, the question of whether white institutions—even the most alternative or radical ones—would ever really be able to accommodate nonwhite participation was an open one.

The fear of black anger fueling the demonization of Pindell may well have informed Artists Space's reaction to the Emergency Coalition's announcement that it would be visiting the gallery en masse on April 14 to discuss the issue. In a flurry of telegrams, Winer and her staff inquired as to the nature of the meeting, demanding details of who would be attending, what form it would take, and what its purpose was. Not receiving satisfactory answers, Artists Space informed the protesters that it would shut its doors on that day so that no one, including the protesters, could enter the gallery. The group instead assembled on the sidewalk outside under a banner that read "Black Artists Locked Out of Artists Space"—a clear indication that for them, the problem was not simply that Donald and his incendiary gesture were let into the gallery, but that they, the protesters, and black artists in general, were kept out. Benny Andrews, cochair of the Black Emergency Cultural Coalition, a group that formed in the wake of the 1969 *Harlem on My Mind* exhibition at the Metropolitan Museum of Art (the subject of the next chapter), led the crowd in chants.

Another meeting was arranged at the gallery on April 21, attended by more than a hundred people (a third of them black, according to an account of the event in the April 26 issue of *The Villager*), the staff of Artists Space, and some of Donald's supporters.[8] The first question, about the lockout of the previous week, was posed by Bob Blackburn, a black artist who was a former member of Artists Space's board of directors:

"Why would a gallery like this fear people like us so much that they would think we would do something?" The debate was, not surprisingly, intense and heated, with charges of racism on one side and overreaction on the other—but what sticks out from the accounts of the day is Winer's statement that in the midst of the protesters' anger, she "felt like a Southern sheriff," a telling counterpoint to Goode Bryant's recollections of her childhood experience of the racial epithet.

•

Almost every one of the letters of support that streamed in over March, April, and May of 1979 to Winer, NYSCA, and the NEA—even those that found Donald's use of the term puerile—pointed to the clear, unique, and even essential value that Artists Space provided in the New York art scene. There was almost no sense that this assessment was not a universally accepted fact—it was spoken of as a given. But in fact, Artists Space's worth—in both an abstract and a material sense, in terms of what it represented and how much money it received from tax dollars—was precisely what those who took part in the protests were questioning. The counterprotesters' focus on censorship, and the framing of the Emergency Coalition and their supporters as lacking sophistication—"if you think this is racism you don't understand art"—was a way of sidestepping what the protesters had made clear from the first moments of the controversy. For

them, the very fact that Artists Space could greenlight a show called *The Nigger Drawings* was clear evidence of what they always knew to be the case: alternative spaces weren't alternatives for them.

Indeed, many made the case in the rawest possible terms at the April 21 meeting with the staff of Artists Space: "Would you have done a 'kike' show? How about *The Kike Drawings*?" shouted people in the crowd. When Winer said that such a show would be treated in the same way as *The Nigger Drawings*, per the gallery's exhibition policy and refusal to censor, artist Camille Billops had had enough: "You're not free to have a *Kike Drawings* [show]! Artists are free to do anything in their studio but you know you can't do that with public funds because they come down on you. You just try to do that. You're full of shit. You know it. You know what power is."

Many of the meetings' attendees spoke of the significance of the incendiary word to the black community, unconvinced that the Artists Space staff and supporters really understood what was at stake for them. It was only when an unidentified woman—whom I presume to be white—said aloud what many felt was the subtext of the whole controversy that the meeting broke down entirely: "This is not a black community."

This unspoken truth—that alternative spaces weren't alternatives for everyone—must have been an especially bitter pill to swallow for those who believed deeply in their mission, especially since the drive to

create an alternative to the commercial art world was specifically meant to bring in those who were being left out in the cold. As Elizabeth Hess noted in her 1979 article in *Seven Days* titled "Art-World Apartheid,"

> Artists Space, which has always enjoyed an excellent reputation, is one of about a dozen places in New York City aiming to provide a genuine alternative to the dominant gallery system, notorious for its exclusion of women and minorities. . . . The alternative spaces were created (and publicly funded) for the purpose of finding this work.

> But the alternative spaces themselves have become "private clubs" for the white avant-garde, according to Howardena Pindell, who asserts that affirmative action is a concept foreign to the alternative galleries as well as the commercial galleries. "We don't think that way," Joan Snitzer, the coordinator of A.I.R., a woman's cooperative gallery in New York, told *Seven Days*. "We want high-quality art and that's what we look for." She noted that A.I.R.'s stable of 20 artists includes a Japanese, a Black, a Chinese, and a Cuban.

In an interview that appeared in *The Villager* in August 1979, Pindell reiterated Billops's assertion that

Artists Space had deployed the notions of artistic free-
dom and free speech in bad faith. "White artists will
say that they want the freedom to express their racism
towards blacks or to express their identity with blacks—
however, blacks are not allowed the freedom to express
their experiences and feelings on the same platform.
This is especially true for blacks in terms of public-
ly-funded exhibitions and alternative spaces."[9]

•

Protesters had suggested from the start a number of
actions that would be appropriate responses to the
larger structural issues *The Nigger Drawings* show
raised; many of these, along with more ideas solicited
in the wake of the April 21 meeting, were adopted in
the plan of action Winer presented to NYSCA on May
22. These included adding minority members to the
board; hiring a part-time consultant "who would be a
minority artist" to bring the work of other people of
color to the attention of Artists Space (in the midst
of the controversy, Winer had disastrously admitted
that she "would have no idea how to curate a show
of minority artists"); partnering with minority-run
alternative spaces to offer programming, and so on.
NEA officers likewise understood that they needed to
pay more attention to the charges of black artists that
their needs were not being met, and to this end invited
Pindell, Billops, and Andrews to Washington, DC to
discuss the issue.

Whatever satisfaction these outcomes might have offered to the protesters, it was the accusation that their actions were a form of censorship that left the deepest wounds. In the aftermath of that explosive spring of 1979, Pindell spoke of being treated as persona non grata in the art world, especially by her colleagues at MoMA—as a sort of black female Jesse Helms. She later told Jeff Chang that she was made to feel like a censor—"the art world's version of a snitch," in his characterization. "Never mind that women and Blacks and people of color were censored *out of the system*," Pindell said, "the issue was: you're censoring a white male artist."[10]

Indeed, what was most galling to many of the protesters was that the charges of censorship leveled at them completely misrecognized or occluded how censorship was and is a completely naturalized, ever-present part of the art world, even in its most radical spaces. In fact, this larger definition of censorship—the kind that kept black people out of the art world altogether, limited their access to funding or exhibition opportunities, dissuaded them from going to alternative art shows by endorsing exhibition titles that represented, for them, a historical and ongoing experience of exclusion and violence—was all the protests were ever about.

From the first days of the protests—in, for example, Goode Bryant's March 14 letter to Carlisle Hart at NYSCA—protesters foregrounded

this phenomenon of "selective censorship." Goode Bryant writes:

> Mere numbers indicate the overt exclusion of minority artists from institutions not designed specifically for their professional development. My day to day activities, encounters with artists and other cultural institutions indicate that the practices of exclusion exist in both "traditional" and "alternate" spaces. The question of censorship is immediately imposed in discussions surrounding situations similar to Artists Space. What often gets neglected is selective censorship; the type of censorship which ethnic groups experience daily.

In an article in the *Village Voice* that appeared two years after the height of the Artists Space controversy, Lippard reiterated this as the major lesson of the debacle and the ongoing struggles around race in the alternative art world. "As Richie Perez of the Committee Against Fort Apache has observed about the lack of positive images of third-world people in the mass media, 'they don't call it censorship, they call it "nobody-is-interested." Freedom of speech is meaningless unless you have the ability to have people hear you,'" Lippard wrote. She goes on to note that unless we come to recognize the censorial function of curat-

ing itself, all forms of protest will be misrecognized as attempts to quash artistic freedom: "If the idea is to leave the selecting to those already in power, even boycotting becomes tabu."

NOTES

1 A bibliographic note: This chapter relies heavily on the archives of Artists Space, which are housed in the Fales Library and Special Collections at New York University. Almost every letter, poster, and press article I refer to in the following pages is contained in these boxes. In order to not clutter the text and make for easier reading, I have standardized some of the spelling and punctuation in my quotations. In addition, I am indebted to Jeff Chang's discussion of the incident in *Who We Be: A Cultural History of Race in Post-Civil Rights America* (New York: St. Martin's Press, 2014), which likewise draws on this archive and also contains information from his conversations with some of the key figures involved and from a recording (now part of the Camille Billops and James V. Hatch Archives, housed in the Rose Library at Emory University) of one of the protest meetings that took place on April 21, 1979 at Artists Space. Coco Fusco refers briefly to the debacle—dwelling primarily on the outcomes of the protests—in "One Step Forward, Two Steps Back?: Thoughts about the Donelle Woolford Debate," (*Brooklyn Rail*, May 6, 2014, https://brooklynrail.org/2014/05/art/one-step-forward-two-steps-back-thoughts-about-the-donelle-woolford-debate). Joseph Henry provides a useful overview of the contents of the Artists Space archives in "Sources of Harm: Notes on the Alternative Artworld" (Hyperallergic, September 11, 2014, https://hyperallergic.com/147841/sources-of-harm-notes-on-the-alternative-artworld/).

2 After the Artists Space debacle, the gallerist Mary Boone took him into her stable of artists, which included Julian Schnabel (one of Donald's supporters, Schnabel collected his work and lent a piece to *The Nigger Drawings* exhibition). Donald eventually moved to Annina Nosei Gallery; but after the controversy over the Artists Space show, his career didn't come to much. He ended up leaving the art world altogether in 1982, returning to California to become part of the nascent tech industry there.

3 Chang, *Who We Be*, 83.

4 The quotation appeared in an article by Richard Goldstein, "The Romance of Racism," *Village Voice*, April 2, 1979; in a letter to Goldstein, Winer insisted she didn't remember saying it. As we will see in the next chapter, the term *nigger gallery* in fact had a much more pointed origin.

5 The amount of this funding is not entirely clear. Both Goldstein and Hess cite the $18,500 number, but Winer in a letter to Goldstein says the three organizations received $17,000, $19,500 and $13,000 respectively, for a combined total of $49,500; however, since these organizations, like Artists Space, regranted a significant amount of their NYSCA funding to smaller groups, this amount was not available directly for programming.

6 Chang, *Who We Be*, 96–97.

7 The protests over *The Nigger Drawings* show first came to my attention when I was asked by Catherine Morris and Rujeko Hockley to participate in a symposium and catalogue for their groundbreaking exhibition *We Wanted a Revolution: Black Radical Women, 1965–85* at the Elizabeth A. Sackler Center for Feminist Art at the Brooklyn Museum (April 21– September 27, 2017). I was asked to write about the "Third World Women" issue of the journal *Heresies*, which was a direct result of the Combahee River Collective's callout of the publication's almost complete erasure of nonwhite experience in its pages. The Committee Against Racism in the Arts published an account of the Artists Space protests in

that issue of *Heresies*. For further context, see my essay "Early Intersections: The Work of Third World Feminisms," in *We Wanted a Revolution: Black Radical Women, 1965–85: New Perspectives*, ed. Catherine Morris and Rujeko Hockley (Brooklyn, NY: Brooklyn Museum, 2018).

8　Chang's account of the meeting pegs the number much smaller—only about three dozen.

9　Janet Heit, "Howardena Pindell: Portrait of the Artist as a Political Activist," *Villager*, August 2, 1979, http://nyshistoric-newspapers.org/lccn/sn83030608/1979-08-02/ed-1/seq-9/png/.

10 Chang, *Who We Be*, 96–97.

Parker Bright, *No Show*, 2018. Mixed media on paper, 19 x 24 in. Courtesy of the artist.

ACT 3

Harlem on My Mind
Metropolitan Museum
of Art, 1969

At the event convened by the Racial Imaginary Institute at the Whitney Museum of American Art to discuss the issues raised by the inclusion of Dana Schutz's *Open Casket* in the 2017 Biennial, the artist Lyle Ashton Harris pointed out that the difficult conversations the museum hoped to have around questions of race and representation have been happening for many years—in exhibitions, research groups, publications, and in artists' studios. That the Whitney was caught off guard by the angry protests against *Open Casket* was a sign that it had ignored the important work being undertaken by black artists challenging the ways museums build walls to protect and bolster whiteness, Harris insisted.

The same could be said of those responsible for one of the most controversial exhibitions in US history, *Harlem on My Mind: Cultural Capital of Black America 1900–1968*.[1] On the surface, the Metropolitan Museum of Art did everything right when it came to what we might now call "diversity and inclusion." *Harlem on My Mind* was imagined as an almost utopian effort to heal a festering racial divide in New York City. It was conceived explicitly as a way to invite heretofore ignored black audiences into the museum. It was put together with a staff that included black collaborators. Three separate advisory committees of black cultural leaders, "influencers," and experts were organized. In other words, it checked off many of the boxes that the protesters of *The Nigger Drawings* show and of the 2017 Biennial demanded of Artists Space and the Whitney, respectively. But despite all of this—or rather because of it—the exhibition failed in spectacular ways.

Thomas Hoving, the recently installed director of the grand encyclopedic museum, said at an August 1968 press conference that he hoped the exhibition would lead to understanding and reconciliation for New Yorkers: "To me *Harlem on My Mind* is a discussion. It is a confrontation. It is education. It is a dialogue. . . . Today there is a growing gap between people, and particularly between black people and white people. And this despite the efforts to do otherwise. There is little communication. *Harlem on My Mind* will change that."[2] What he did not seem to realize, despite every opportunity to do so over the course of the

almost two-year-long planning process for the show, is that he was stepping into a conversation that had already started, in a community—of Harlem artists, writers, and cultural activists—that didn't simply want to be *engaged* by historically white museums like the Met. They wanted to participate fully, by shaping the narratives and histories that those museums offered to the public, a public that included people like them.

•

The idea for *Harlem on My Mind* was born in 1967 thanks to a meeting of minds between Hoving and Allon Schoener, a curator who was making waves with his radical approach to conceiving exhibitions. Hoving had just come from a stint in Mayor John V. Lindsay's administration as parks commissioner, where he was known for trying to calm the rumbling undertow of racial unrest in New York by programming "be-ins, love-ins, traffic-free bike ridings, Puerto Rican folk festivals, and happenings" in public spaces, as one journalist put it.[3] He was brought on by the board of trustees earlier that year to shake things up at the venerable art museum. "He'll make the mummies dance," Mayor Lindsay quipped at the time.

He had new ideas and a plan—a master plan, as it turned out. In April 1967, Lyndon B. Johnson had announced that the Temple of Dendur, which had been gifted to the US by the government of Egypt, would be entrusted to the Met. (The New York mu-

seum beat out the Smithsonian Institution in Washington, DC and the Boston Museum of Fine Arts for the honor.) The question now was, what to do with it? Hoving wanted to expand the footprint of the museum to create a space to house it, and while he was at it, to expand the "primitive" collection of African and Oceanic art that had been donated by Nelson A. Rockefeller, build a new wing for the Robert Lehman Collection of European art, and renovate the existing galleries—for a projected cost of $50 million (over $350 million in today's terms).

It wasn't simply the price tag that raised eyebrows, although that was no small consideration. A number of groups, including the activist Art Workers' Coalition, opposed any further encroachment of the museum into Central Park, not wanting to see any more ceding of public resources to private interests. While the Met was not exactly private, it was not truly public, either: Hoving himself recalls that when he first arrived, he "found that the Irish guards at the main entrance actually turned away African Americans and Hispanics saying that the [Metropolitan Museum of Art] was a private club."

There were also calls by black community groups, politicians, and activist organizations to consider putting the Temple of Dendur in Harlem. Some took the opportunity to suggest that the Met install parts of its collection in satellite museums around the five boroughs, too, the better to reach underserved, often minority communities who didn't feel welcome on Fifth Avenue.

For all Hoving's populist work at the parks department, his desire to go back to the founding mission of the museum (which included a commitment to find ways for its programming to apply itself to "the practical side of life"), and his determination to open the door to a broader swath of the city's residents, he had no intention of dispersing the Met's resources or collection. He knew that in order to get his master plan past the various committees and city council, he would have to show that the museum could become a valued resource for black and brown residents, and that it could reach out into underserved communities and enclaves *without* actually having a physical footprint there.

The tool that he eventually settled on to achieve this goal—*Harlem on My Mind*—was subtitled *Cultural Capital of Black America.* The irony of the wording is perhaps only apparent in retrospect. It hinges on the double meaning of *capital*—a term that refers to Harlem as a place, of course, but also hints at the way in which blackness is traded as a currency, a form of that other kind of capital. As would become apparent to many critics of the show, Hoving and his colleagues were using the idea of black outreach and community engagement as a means to an end—to retain the integrity of the Met in the face of pressures to open itself to those it had long kept out.

•

Hoving started looking around for ideas on how to achieve his goal of making the Met more relevant for

black audiences in short order. Enter Schoener. The curator had made his mark shortly after his arrival in New York with an extremely popular show at the Jewish Museum in 1966 called *Portal to America: The Lower East Side, 1870–1925*. The exhibition was a deep dive into the storied neighborhood, tracing its character as it morphed with the influx and rising and falling fortunes of waves of Eastern European Jewish immigrants.

While visitors ate up the narrative of the immigrant success story offered by *Portal to America*, they were equally thrilled by the innovative curatorial approach. Schoener, an admirer of the designers Charles and Ray Eames and other visionaries who were offering new ways to think about visual communication, had created a multimedia extravaganza, using photographic blowups, slide projections, soundscapes, film, newspaper reproductions, and text panels to conjure the experience of the neighborhood and its inhabitants. In doing so, he was combining up to date research in communications theory with a desire to subvert the elitism of the museum. He wanted to undermine the hierarchies on which art museums were largely based, hierarchies that treated painting and sculpture as the apogee of art while ignoring other forms of visual culture (television, film, advertising, and even photography). He also sought to empower individual visitors to create their own narratives as they moved through a "communications environment." Schoener explained his philosophy this way: "The individual who responds

to an experience becomes as important in the communications process as the one who organizes it. In other words, the audience itself becomes a creative force. . . . This suggests a new aesthetic hierarchy."[4]

After talking to two black ministers in the galleries of *Portal to America*, Schoener realized that Harlem, one of the most culturally significant black enclaves in the US, should be the subject of a show like this one. When he pitched the idea to Hoving, the Met director agreed immediately, seeing the exhibition as an opportunity to shake up the venerable institution in a number of ways. It would be the first-ever show to acknowledge African American culture at the museum; while African artifacts were staples in the galleries, the works of American black artists had never been shown. It would be the Met's first exhibition of photography—which was still not considered "fine art" by most museums and many artists at the time. (This would be a key issue in the protests, as we will see—the idea that photography was not an art, and photographers were not artists.) And, most important, it would be a demonstration of the museum's commitment to expand its audience and an opportunity to cultivate ties with the Harlem community—something Hoving needed to demonstrate to politicians, city residents, and activists in order to curry favor for his master plan.

Both Schoener and Hoving explained their commitment to the project in idealist terms—perhaps sincerely in Schoener's case, largely opportunistically

in Hoving's. Schoener considered his radical approach to museum exhibitions part of his larger political commitments. He called himself a Marxist, and believed strongly in social justice issues, including civil rights. He even saw his work as a curator as a form of activism: "What can I do that will contribute to what is happening in the country today?" he recalls thinking. "I knew how to make exhibitions, so I thought, why not make an exhibition that's revolutionary?" When he dedicated the exhibition catalogue "to the people of Harlem—past, present and future—as a record of their achievements," he was doing so with the utmost sincerity. Hoving, too, invoked the language of social engagement when he announced the upcoming show on November 15, 1967, at a press conference attended by Mayor Lindsay and the powerful Manhattan borough president Percy E. Sutton: "This isn't going to be a white hand-out to Harlem," he insisted. "The Museum's role is simply that of a broker for channeling of ideas. You might say we're attempting to tune in on something we've been tuned out on."[5] In the press release sent out that day, he portrayed the Met's role as a kind of arbiter of racial relations in a troubled time: "At no time in this country's history has there been a more urgent need for a creative confrontation between white and black communities than today. In the belief that the Metropolitan Museum of Art has a deep responsibility to help provide the opportunity for such an exchange, an exhibition of Harlem's rich and varied sixty-year history as the cultural capital of

Black America will be shown in the Museum's major exhibition galleries."

Hoving saw the Met as a site of "creative confrontation" (another term for "difficult conversations," it seems), as a benevolent, neutral platform where not just opposing ideas but communities in conflict could come and work out their differences. But thanks to the emergence of the Black Arts Movement, itself fueled by the language of black nationalism, the Harlem cultural community had a much different, and indeed progressive, idea of what museums were and what they could be. Black organizers, recognizing them not simply as neutral platforms for display and debate but as mechanisms of power, sought to intervene in existing institutions—as well as create new ones—in ways that foregrounded museums' roles in their communities, including acting as an active force in the struggle for racial justice. They were after transformation, not inclusion.

That transformation would hinge on black people being able to tell their own stories. In the late 1960s, a wave of artist-activist groups, storefront galleries, collectives, and nonprofits emerged in Harlem and other boroughs in New York that gave black artists places to learn the history of African American art, develop their skills, and, above all, show their work. Understanding the challenges faced by those they served, the founders of such sites included childcare, studio space, school outreach, and prison education in their operations. Among these institutions were galleries

such as the Weusi Artist Collective's Nyumba Ya Sanaa; Acts of Art Gallery; MUSE; Studio O; Operation Discovery, Inc.; Queens Storefront, and groups like Spiral, founded by Norman Lewis, Romare Bearden, and others in 1963.[6] The list also included the Studio Museum in Harlem, which, after a three-year incubation, opened its doors on September 24, 1968—just months before *Harlem on My Mind*—and immediately became not only a platform for debate but an active and even activist entity, determined to shape new histories of art as well as critique its peer, white-focused institutions.

While there were widely differing ideas within the black arts community about whether black artists should focus on gaining access to historically white museums and galleries or building an entirely separate infrastructure around the idea of black excellence, there was little doubt they were being poorly served by the standards imposed by mainstream institutions. When curators and critics spoke of the need to base curatorial decisions on "artistic quality," for example, black artists heard not only "you're not good enough," but also, even more importantly, "you don't belong here." The poet Etheridge Knight pointed out that it was imperative to recognize that "universal" standards are neither race-neutral nor inappropriate when black and white people have such radically different experiences of the world: "The White aesthetic would tell the Black Artists that all men have the same problems, that they all try to find their dignity and identity, that

we are all brothers and blah blah blah. Is the grief of a black mother whose 14-year old son was killed by a racist the same as the grief of a WASP mother whose son was killed in a Saturday afternoon football game?"[7]

In this context, black artists and cultural denizens received news of the forthcoming *Harlem on My Mind* with some reticence, feeling that, for all the rhetoric, the show was not really concerned with black people. Instead, they predicted, it would end up being a way to capitalize on a kind of "radical chic" that was circulating in elite circles in New York at the moment, where the 1 percent (to use an anachronistic term) could rub elbows with black nationalists, anti–Vietnam War activists, and leftist politicos without actually having to give up their power, resources, or authority.[8] As it turns out, they were not off the mark.

Edward Spriggs, the newly appointed director of the Studio Museum, assessed Hoving's resource-hungry master plan in similar terms. In a seminar sponsored by the New York State Council on the Arts and the Department of Cultural Affairs, he characterized the museum's expansion not simply as a matter of budgets and space, but as part of a much larger process of the marginalization of black people and black culture:

> This is the age of the master plan. I am sure that we have all become aware of master plans in the last few years—plans of the masters. It's the age of hidden agendas

which characterize and camouflage white imperialism and racism; white nationalism; white regionalism; white provincialism; as well as institutional racism. . . . I'd like to see the major institutions begin to redistribute the wealth of continents like Africa that has been ripped off over the years, raped, plundered, etcetera, for the benefit of private collections and museums in this country.

For Spriggs and many of the other artists and activists whom the Met had hoped would end up being enthusiastic cheerleaders of their foray into Harlem culture, it was clear that any offers of "inclusion" were not going to be enough. They wanted a seat at the table, a voice in the galleries, and a share of the resources. In other words, they wanted to be fully represented in the cultural institutions that had been built largely on the wealth they and their forebears had helped to create.

•

Schoener was certainly aware of the optics of having a white Jewish man curate the Met's first exhibition devoted to black culture. To mitigate this problem, he surrounded himself with people who, he hoped, would burnish his credibility and reassure the Harlem cultural community that their voices were being heard.[9]

The first thing he did was hire a team that included three African Americans: Reginald McGhee, who was in charge of photographic research; Donald Harper, who was tasked with creating sound recordings for the galleries; and A'Lelia Nelson, who was hired to be project administrator. (That McGhee and Harper were black but not residents of Harlem would become a point of contention down the line.) Schoener also assembled a research committee consisting of three members, all Harlem residents, and all black: John Henrik Clarke, an activist, scholar, editor of *Freedomways* (a black leftist journal), and author of *Harlem U.S.A.* and *Harlem: A Community in Transition,* two important works of cultural history that would, though uncredited, provide much of the historical structure for the show; Jean Blackwell Hutson, curator at the Schomburg Center for Research in Black Culture in Harlem; and Regina Andrews, the first black librarian in New York City and an expert on the neighborhood. A third committee was eventually set up—a "community advisory committee" that included Ed Taylor, head of the influential Harlem Cultural Council, and a few dozen other people who were meant to be ambassadors for *Harlem on My Mind* among Harlem residents. Additionally, Schoener and Hoving sought endorsements from the likes of Harlem congressman Adam Clayton Powell Jr. and William H. Booth, chairman of New York City's Human Rights Commission. The preparations for the show happened at three locations: across the street from the Met; at the offic-

es of the New York State Council on the Arts, where Schoener was still employed while curating *Harlem on My Mind*; and at an outpost in the Schomburg Center in Harlem.

But an awareness of the optics, it turned out, was as far as Schoener's understanding went. Whatever his sense of "inclusion" was, it didn't encompass the kinds of roles that black artists and cultural leaders were seeking or had been led to expect. Criticism seemed to arise almost as soon as the planning began in August 1967. There was the inevitable suspicion about whether Schoener, as a white man, would have any meaningful insight into the life and history of Harlem, or whether he was just taking advantage of black history to accrue cultural capital and prestige for himself. Schoener's attempts to include black voices on the curatorial team backfired to a degree: there was rumbling about the fact that while Harper and McGhee were both black, neither man was from Harlem, and so would have no meaningful insight to offer about the neighborhood. The research committee and community advisory committees both expressed frustration in meetings and in letters to both Schoener and Hoving that while everyone was listening to their suggestions, no one was taking any action on them. Ed Taylor of the Harlem Cultural Council was offered a paid advisory position, although the terms of the invitation were vague; he eventually withdrew from participating altogether, believing the museum hadn't followed through on including him in any actual plan-

ning decisions for the show.

As the planning process developed, everyone began to realize what Schoener later admitted: the consultants from the Harlem community were just there to provide him cover and legitimacy. As Clarke would put it in a letter to Bearden in August 1968, "The basis of the trouble with this project is that it never belonged to us and while a lot of people listened to our suggestions about the project, very few of these suggestions were ever put into effect."

But the greatest objection—even outrage—focused on the fact that in the first-ever exhibition of African American culture at the Metropolitan Museum of Art, *no black art was to be included.*[10]

Schoener's *Portal to America* exhibition had included a room of paintings by artists active in the Lower East Side during the period in question, but Schoener came away thinking it was the least successful part of the show. To his mind, it interrupted the documentary character he was going for, which hinged on anonymous black-and-white images, both photographic and filmic, that had the quality of (and were primarily drawn from) wire services. Including paintings and sculptures by black artists didn't fit with his curatorial conception. For Schoener, it was no more complicated than that: "I thought [black artists] deserved to have their art dignified by being presented at the Metropolitan Museum—I never questioned that," he later recalled. "But I didn't see that as my responsibility."

To many, it was becoming clear that the only artist who would be on view in *Harlem on My Mind* was Schoener himself: it was his vision that was paramount. For painters and sculptors who had been systematically excluded from institutions like the Met, and who had become increasingly impatient with such exclusions, this did not sit well.

Hoving tried to justify the Met's break with tradition in not focusing on art and artists, and instead dwelling on the "non-art," documentary medium of photography, by elevating the people of Harlem to a creative, generative role in his descriptions of *Harlem on My Mind*. "There is no difference," he claimed, "between this show and one of Rembrandt or Degas. Through their works, these artists reveal their individual worlds to us. The Harlem community becomes the artist in this case, the canvas the total environment in which Harlem's history was formed."[11] But Hoving's words rang hollow. As became clear by the museum's repeated refusal to listen to the input and expertise of black cultural leaders—even those on their own advisory committees—the Harlem community was not the artist at all but merely the artwork—the object of Schoener's will, not the subject, the maker, the creative producer.

The controversies at the Whitney in 2017 and Artists Space in 1979 involved a tangled web of arguments: questions concerning the institutional power of white art institutions got mixed up with or obscured by condemnations of the work of individual artists,

and so the debates ended up focusing largely on the issues of artistic freedom, free speech, and censorship. But at the Met in 1969 no such thing occurred. The protesters were clearly and unequivocally challenging the curator's and the museum's refusal to cede control to black expertise, even in the most minimal ways. And the museum—with no artist to hide behind—had to respond.

•

The curatorial team was getting whiffs of an impending disaster as early as January 1968, a year before the show's scheduled opening. In May, Taylor had written to Hoving expressing his concern: "I find it distressing that a [Romare] Bearden, [Ernest] Crichlow, or [Roy] DeCarava has not been added," he wrote, citing three stars of the Harlem art firmament. "As one very young photographer put it: 'How can we have a show of such major proportions without some of the truly great Afro-American artists being involved[?]'" By June, research committee member Clarke wrote to Schoencr, warning that the show should be substantially changed or even canceled. Clarke charged that in its goal of presenting a social document of Harlem rather than the actual artistic legacy of Harlem, the show was more suited to the Museum of the City of New York than the venerable Metropolitan Museum of Art. Bearden also suggested that the show be canceled, given the Met's mishandling of the Harlem community.

There was a growing militancy around the issue as the summer of 1968 wore on. The museum attempted more community outreach to calm the waters, with decidedly mixed results. When a member of the Met's newly established community relations team went to meet a group of Harlem-based artists to "listen to their concerns," the group demanded that the entirety of the Luce Foundation grant that was underwriting the exhibition—$225,000—be given over to Harlem artists, and that the exhibition be put entirely in their hands.

By the fall, the members of the research committee had dissociated from the exhibition and started allying themselves with some of the artists pushing back on the conception of *Harlem on My Mind*. Hoving and Schoener were getting increasingly panicked, and in an attempt at crisis management, Hoving invited Bearden to take on a position as curatorial adviser—not for the *Harlem on My Mind* exhibition itself, but for a show of black contemporary artists that would run more or less simultaneously. In other words, black artists would not interfere with Schoener's curatorial vision, but they would not be locked out of the museum entirely, either. Bearden suggested two possible curators for this ancillary display—James Porter, author of *Modern Negro Art* (1943), who directed the art department and gallery at Howard University, and the art historian Carroll Greene Jr.—and also suggested that Hoving meet with DeCarava, the revered photographer of Harlem street life, for inclusion in the main

event. Hoving ignored Bearden's suggestions, and instead put the black contemporary art show in the hands of three other Harlem-based curators: James Sneed, who had cofounded the Twentieth Century Creators, Taiwo Yusef Shabazz, and Ademola Olugebefola, one of the founders of the Weusi Artist Collective. Major black artists largely ignored their call for submissions to the planned juried exhibition. As Benny Andrews, a painter who would become one of the key figures in this and future protests, put it: "It was not something that we gave any importance to 'cause it was not being approached in a way that was really going to *mean* anything. . . . I'd been exhibiting on Madison Avenue, like one or two of the other people, so we knew what good exhibitions were. We were not that hungry to have something thrown at us."

The concurrent exhibition of contemporary black artists never came to pass. Instead, the Met's education department put up a small show of the work of Harlem schoolchildren.

•

In October 1968, only three months before the exhibition was to open, and at the point that relations between the museum and the Harlem community had broken down almost beyond repair, another event blew up on the New York art scene: the opening of the William Agee–curated exhibition *The 1930's: Painting and Sculpture in America* at the Whitney Museum of

American Art. Not a single black artist was included in the show. The relatively amorphous activism among black artists coalesced into something more formal at this point: Faith Ringgold, Andrews, and others picketed the Whitney on November 17. In addition to this direct action, the activists also mounted a counterexhibition at the Studio Museum in Harlem, *Invisible Americans: Black Artists of the 1930s*, curated by Henri Ghent, an artist who also served as the director of the Community Gallery at the Brooklyn Museum. The show made clear the activists' determination to have a voice in shaping art history, in addition to promoting the work of individual artists. It opened two days after the Whitney exhibition and ran until two weeks before *Harlem on My Mind* opened.

Many of these same figures spoke at the November 22 press conference called by the Harlem Cultural Council to announce their withdrawal of support for *Harlem on My Mind*, including Andrews, Bearden, and DeCarava. Taylor summed up the general feeling that the Met had tried to dupe Harlem with its empty offers: "The Met came to us with elaborate promises of community involvement in the show. But they haven't really begun to consult us. We're expected simply to be rubber stamps and window dressing."[12] Grace Glueck, who reported on the event for the *New York Times*, cited a "breakdown in communications" and the fact that Clarke and Hutson, members of the research committee, were being ignored in favor of the "out of towners" McGhee and Harper.

On January 7, 1969, less than two weeks before the show was set to go public, Hoving requested an

emergency meeting with some of the leading artists and cultural figures in Harlem to make a last-ditch effort to get them on board. The meeting must not have gone well, because two days later Andrews, Bearden, Ghent, Cliff Joseph, Lewis, Taylor, and a number of others met at Andrews's loft and formed the Black Emergency Cultural Coalition. While the group was organized specifically to protest *Harlem on My Mind*, it would go on to become a major voice and model for artist activism in the coming years—including, as we've seen, in the protests around *The Nigger Drawings* show at Artists Space a decade later.

The BECC had three immediate objections to the exhibition: the absence of black curators at the Met, the museum's lack of meaningful action in response to the input of black advisers in the *Harlem on My Mind* exhibition, and the fact that a show about black culture would not include the work of black painters and sculptors. They called for the show's cancelation, for the appointment of black professionals to policy-making and curatorial positions at the museum, and for the museum to develop a "more viable relationship" with Harlem residents and the black community at large.

•

Starting on January 12, a few dozen protesters turned up in front of the imposing facade of the museum to demonstrate in advance of the show's public opening, handing out leaflets and urging visitors not to attend the private advance viewings. The picketers included members of the black arts groups Spiral (including

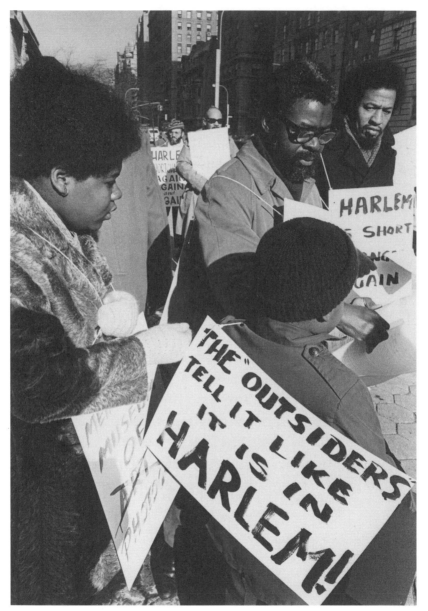

Thomas Patsenka, *Protest at the Metropolitan Museum of Art*, January 12, 1969. Photograph. Courtesy of the artist.

Lewis and Reginald Gammon), Weusi, and others (for example, the white painter Alice Neel, a longtime resident of East Harlem), who now joined with Andrews, Vivian Browne, Ghent, Joseph, and others under the auspices of the Black Emergency Cultural Coalition. They represented multiple generations and political stances, ranging from those who favored integrating historically white institutions to those who wanted to reject them outright. Andrews and his colleagues from the BECC took the lead. The protesters wore sandwich boards that said things like "On the Auction Block Again—Sold Out by Massa Hoving," "That's White of Hoving!," "Tricky Tom at It Again?," "Up from Slavery—Not yet Says Uncle Tom," and so on, slogans that spoke to a continuing exploitation of blackness by white culture, in this case in the form of cultural capital rather than literal slavery, but connected nonetheless. Andrews described the scene as follows:

> At 1:00 pm we started our demonstration at the Metropolitan against the *Harlem on My Mind* show. The police were waiting for us with barricades and very stern looks. A line of the Museum's staff were right inside the Museum with their noses pressed against the glass doors peering out at us. We formed a long oval line and started to walk slowly around and around the police barricades with

our placards denouncing the exhibition. The passing pedestrians and street traffic practically came to a halt when they spotted this small slow line of Black people in front of this massive, angry, forbidding, endless façade of the Metropolitan Museum of Art.[13]

Members of BECC, as students of the larger black nationalist movement, were canny about leveraging media attention—especially when it came to taking advantage of the police's fear of black protest and the media's (racist) hunger for images of black militancy, a common sight in nightly news broadcasts at the time. The BECC needed media attention, wrote Andrews later, because "That's all we had. We had no money. We had no influence. We had no entrée into the white museum structure. . . . I'll never forget how little we looked there. . . . Fortunate for us we got window dressing because the police came, set up barricades. . . . It was almost like giving us some clothing to wear."

While Andrews was one of the key organizers of the demonstrations, his was not the face appearing on New Yorkers' television screens as the representative of the BECC. Knowing the media was looking for an image of "black militancy"—an image that required a dark complexion, not Andrews's light skin—he took a back seat to his coconspirator Ghent. For all the militant posturing, however, there were limits to what the protesters would countenance. Gammon, a member

of Spiral and the BECC, recalled, "There was a guy we threw off the picket line because he was passing out red sheets saying, 'Bomb the Metropolitan!' We wanted to be in this place eventually! He was a total nihilist."[14]

•

The protests gained steam over the next few days. Some museum visitors and an elite coterie of influential New Yorkers joined the picketers. Then, on January 16, something strange happened. The BECC came to the museum only to find other protest groups gathered there, too—including members of the Anti-Defamation League, the Jewish Defense League, the American Jewish Congress, and (bizarrely enough) the ultraconservative John Birch Society. Each group set up on a different part of the plaza in front of the museum, but the total effect was striking. The Met, that imposing stone fortress of art, was under siege.

The Jewish groups were there not to decry the exhibition itself, but the catalogue for the show that Schoener had put together. Instead of taking the advice of his publishers or his advisers, the curator chose not to have an authority on Harlem write the introductory essay. The original publisher, who eventually refused to issue the book, had suggested Ralph Ellison as a possibility; Schoener rebuffed the suggestion, insisting that he wanted an essay by an "unknown voice." It may be that Schoener was eager to create opportu-

nities for young black writers—he had, for example, urged the Met's press office to suggest to all the major magazines that they hire black writers to write about *Harlem on My Mind*. But given his treatment of his advisory committees, it was more likely that he was eager to retain control of the show as the sole voice of authority. Schoener at first floated the idea of having a young black militant contribute to the book—he was enamored of the romance of black activism, as was clear from some of his curatorial decisions in *Harlem on My Mind*, including the outsize role played by Malcolm X in the show. But he eventually settled on a research paper written by Candice Van Ellison, a high school student at Theodore Roosevelt High School in the Bronx. Van Ellison was an intern in the Ghetto Arts Corps program at the New York State Council on the Arts when McGhee, and then Schoener, came across her paper.

Van Ellison's essay as published in the exhibition catalogue was filled with a frank discussion of anti-Semitism in the black community, including the following lines: "psychologically, Blacks find that anti-Jewish sentiments place them, for once, within a majority. Thus, our contempt for the Jew makes us feel more completely American in sharing a national prejudice." This passage, among others, drew the ire of Jewish protesters. The president of the Anti-Defamation League, Dore Schary, called it "something akin to the worst hatred ever spewed out by the Nazis."[15]

It should not have come as any surprise that

such comments would have sparked anger, especially attached to an exhibition about black culture curated by a Jewish man, given that the two communities were increasingly at loggerheads. Though they had seemed a natural coalition during the early years of the Civil Rights era, tensions between blacks and Jews were intensifying across the country, and came to a head in New York City in the summer before *Harlem on My Mind* opened, in a battle around community control of schools.

Groups of largely black residents were questioning the ways in which decision-making power and resources were monopolized by citywide bureaucracies, leaving local "ethnic" enclaves without a real say in their local institutions. This issue was at the heart of the 1968 teachers' strike. Black residents of the Ocean Hill–Brownsville neighborhood in Brooklyn and other minority parents wanted to play a more active role in their children's education. The city agreed to experiment with mechanisms of local control, but in the process abruptly laid off a significant number of public school teachers and administrators who were, as it happens, predominantly Jewish. The teachers walked off the job in furious protest. The battle raged not between a united front of unions and local groups against the city, but between the unions and community members themselves. Albert Shanker, the head of the powerful United Federation of Teachers, who was not above making his arguments for the preservation of teachers' jobs in outright racist ways, did not help matters; his vitriol was

returned in kind.

In this poisonous atmosphere, the comments contained in the introduction to the *Harlem on My Mind* catalogue were bound to meet with outrage. What no one knew at the time was that these statements were not originally Van Ellison's. They derived, in fact, from a respected 1963 sociological study, *Beyond the Melting Pot: The Negroes, Puerto Ricans, Jews, Italians, and Irish of New York City*, coauthored by a Jewish scholar, Nathan Glazer, and an Irish-American politician and academic, Daniel Patrick Moynihan. (Moynihan, a right-leaning Democrat in the Nixon administration who would later serve as US Senator from New York, was the author of the notorious 1965 study *The Negro Family: The Case for National Action*, which placed the blame for poverty in black communities on the prevalence of out-of-wedlock births and households headed by single mothers. The argument would play a crucial role in the Republican-driven "welfare reform" legislation of the 1990s.) As a small-time newspaper reporter at the *Park East News* revealed in the wake of the protests, the most offensive lines in Van Ellison's original paper were actually quotations from Glazer and Moynihan's book. But when the essay was transformed for the *Harlem on My Mind* catalogue, these same passages were paraphrased as Van Ellison's own sentiments, with the quotation marks removed.

The change had come at Schoener's request, along with the replacement of Van Ellison's more neutral use of the term *Negro* with the more radical sound-

ing *Afro-American* and *black*. He was concerned that the essay read as "authentically black," which to his mind required militancy, anger, and hard truths rather than the cool tone of a young researcher and emerging scholar. Schoener spun the decision as having a liberal political intent when he spoke about it years later: "Everyone was into black nationalism and black identity and it was very important for black statements to be listened to by white people. So for me to say in the introduction that this was a young black woman who was borrowing from white intellectuals would have been very inappropriate." This move, yet another based on Schoener's stereotypical vision of black life and his insistence on using black contributors solely as mouthpieces for his own political view of race relations, was disastrous for the museum.

The American Jewish Congress took out a full-page ad in the *New York Times*. The protests went from being buried in the back of the paper (when they only involved the BECC) to being splashed on its front page. Mayor Lindsay, whose standing among the Jewish community had been damaged by the teachers' strike, and who was facing a tough reelection campaign, called Hoving to pull the catalogue. The *New York Times* editorial board declared that to suppress the catalogue "would be book burning without the flames, an even greater offense to American traditions than anything in the book."[16]

Schoener was likewise appalled at the idea. He was worried that if Hoving censored the catalogue, it

would reflect badly on his editorial decision-making. Hoving at first refused Lindsay's demand, which he may well have understood as merely a necessary polit-ical posture on the mayor's part in a tumultuous elec-tion year. Hoving eventually agreed to the insertion of a disclaimer, and then apologized publicly, but to little effect. It took Lindsay's threat to cut off the city's $3.5 million funding to the museum to get Hoving to finally acquiesce.

On January 24, twenty-six thousand copies of the softcover version of the catalogue—which had been selling at the rate of a thousand per day, thanks to a below-cost cover price of $1.95—were relegat-ed to the basement. This quelled the outcries of the Jewish groups. To quiet the John Birch Society, whose members were marching in the cold to protest the fact that a pop-up bookstall for *Harlem on My Mind* was also offering the works of communists such as W. E. B. Du Bois, Frederick Douglass, and others, Hoving also pulled those volumes.

The only demands that were not met were those made by the BECC.

•

Just as the BECC had found itself elbow to elbow with the most unexpected groups on the picket lines, they also found some of their complaints echoed by art crit-ics of all political bents. One of the BECC's key conten-tions was that the Met was disrespecting black people

by having the story of Harlem culture told exclusively through the medium of photography—a medium that was still not considered "art" by most traditional art museums. *Harlem on My Mind* did in fact introduce museumgoers to the photographs of James Van Der Zee and Gordon Parks, two of the great African American chroniclers of black culture. McGhee is credited with "discovering" Van Der Zee, happening across his work when he walked by the elderly photographer's studio window. This lucky accident ended up being a pivotal moment for Van Der Zee's career, garnering him well-deserved attention and a number of honors in subsequent years.[17] But this narrative of discovery obscures the equally important fact that Schoener and his team had refused to seek the advice of experts like DeCarava—who was also the first director of the Kamoinge Workshop, a collective devoted to bolstering the visibility of black photographers—despite the urging of members of his own advisory committees. By doing so, the curator overlooked a great deal of work being done already to document Harlem from a specifically black point of view.

The Kamoinge Workshop was established in the early 1960s, and in its rented gallery and meeting space in a Harlem brownstone the group organized lectures, exhibitions, and critiques and published photographic portfolios.[18] Among its founding members was Louis Draper, who described the workshop as a site of mutual support in the face of exclusion by white institutions: "We saw ourselves as a group who were trying

to nurture each other. We had no outlets. The magazines wouldn't support our work. So we wanted to encourage each other . . . to give each other feedback. We tried to be a force, especially for younger people." Among other activities, the group published a widely celebrated portfolio in the Swiss periodical *Camera* in 1966, titled "Harlem," consisting of photographs taken from insiders' perspectives that were meant to counter stereotyped views of the neighborhood.

Not only did Schoener's curatorial narrow-mindedness reproduce the kinds of historical barriers that led to the establishment of the Kamoinge Workshop in the first place, but it also demoted photography to a purely instrumental role. In the installation, images were rarely identified with the names of their creators, and were often blown up and cropped in order to conform to the exhibition's overall design. This was one of the main reasons DeCarava, whose work had already been shown at the Museum of Modern Art to great acclaim, refused an invitation to participate in *Harlem on My Mind*. In his letter explaining the decision, he wrote that "it is evident from the physical makeup of the show that Schoener and company have no respect for or understanding of photography, or, for that matter, any of the other media that they employed. I would say also that they have no great love or understanding for Harlem, black people, or history."[19]

But for the BECC, even the presence of black *photographers* did not make up for the absence of black *artists*. At least one picketer carried a sign that read,

"Visit the Metropolitan Museum of Photography" and a leaflet passed out to passersby stated the following:

> One would certainly imagine that an art museum would be interested in the world of Harlem's painters and sculptors. Instead, we are offered an audio-visual display comparable to those installed in hotel lobbies during conventions. If art reproduces the very soul of a people, then this rejection of the Black painter and sculptor is the most insidious segregation of all.

The BECC also warned in another leaflet:

> Those persons coming to the exhibit, in the world's major museum, expecting to see the aesthetic dimension of Black American experience will be disappointed—THE MET HAS GIVEN UP ART FOR SOCIAL SCIENCE.

The reviews of the show were generally quite harsh, on many different levels. Grace Glueck of the *New York Times* and Cathy Aldridge of the black newspaper *New York Amsterdam News* both found the cacophonous design, the lack of labels and explanatory text, and the overabundant display to be a capitulation to cheap media culture and a disservice to the medium

of photography. But others, including John Canaday of the *New York Times*, took up the BECC's critique. He lambasted the Met's apparent abandonment of its mission as a custodian of art in favor of sociology; so incensed was he that his whole review was a diatribe about how he was not equipped to review the show because he was an art critic, not a social scientist. Hilton Kramer, also writing in the *Times*, likewise saw the exercise as a sign that the Met was "abandoning art for a cheap form of photo-audio journalism" and for "social evangelism"—with an amateurish result at that.

If there was an alignment between the BECC's mockery of the Met's shift to photography—the expansion of its definition of "art" to include visual culture more broadly—and the critiques by conservative critics, it was only in superficial terms. For the protesters and their allies, the issue went to the heart of how black Americans were perceived as subjects, not some reactionary definition of "pure art." When William T. Williams spoke at a Met-organized symposium titled "The Black Artist in America," convened just before *Harlem on My Mind* opened in January 1969, he explained why the Met's sociological turn was in fact deeply racist—and why the problem was not limited to this exhibition:

> One of the things that's happening is that every show that concerns Black artists is really a sociological show. The *Harlem on My Mind* show is a pointing example of total rejection on the part of the estab-

lishment, of saying "Well, you're really
not doing art," or of not dealing with the
artists that may exist or do exist in Har-
lem. These shows deal with the sociolog-
ical aspects of a community, a historical
thing.

There was a worry, too, that the sociological
dimension was continuous with a much darker, and
not so far removed, history of anthropological study,
whereby black people were included in museums as
specimens, living or preserved. The fact that most of
the documentary photographs in the show were made
not by members of the community, but by outside
observers, largely white, only exacerbated this suspi-
cion. Charles Wright, a black critic at the *Village Voice,*
evoked this history in a review published soon after
the opening, in which he described the crowds waiting
to see the show as lined up to see "freaks at a zoo."[20]

•

For all the controversy, the exhibition was exceed-
ingly popular—attended by 450,000 visitors over its
sixteen-week run, compared to a typical attendance
of fifty to sixty thousand for a show of its scale. The
museum had to close early some days because they
had reached capacity. Although Schoener and his
exhibition designers had meticulously planned the
displays and traffic flows to result in a sixty-minute
viewing experience, many stayed longer. A large num-

ber of visitors were black, and it is likely that many of them had never entered the Met before. This was disappointing to the protesters. As Mahler Ryder of the BECC explained, "many black people who hungered for their images crossed the picket line, including lots of teachers who took black children across the picket line." (The comment about teachers should be read in light of the recently settled Ocean Hill–Brownsville teachers' strike—that is, evoking black residents' lack of control over their kids' education.)

This popularity, including the size of the black audience, did not mean that the Met had achieved its goals for the show, however. As a result of the brouhaha it became clear that local politicians would not get behind the Met's master plan without the actual sharing of resources that the museum was trying to avoid. In November 1969, the trustees announced the formation of a committee "to study the cultural needs of New York communities not directly served by the Metropolitan or by other major art museums." Significant money was set aside to develop cultural programs and lend art from the collection to community organizations and small museums around the city, to train members of minority groups who wanted to pursue careers in museums, to offer summer internships, and to run educational programs off-site. Over the next six years, it oversaw the creation of four art museums—including the Bronx Museum of the Arts, the Snug Harbor Cultural Center in Staten Island, and the Queens Center for Art and Culture (later the Queens

Museum)—and held major exhibitions at eight external locations.[21] These efforts were two things at once: a welcome outcome for underserved communities in the city, and a measure of how far the Met was willing to go to resist opening its Fifth Avenue fortress to blackness.

The biggest consequence of *Harlem on My Mind*, however, was the way it galvanized the black cultural community in the coming years. Buoyed by the visibility and traction they had achieved in their protests against the Met, the BECC turned its attention again to the Whitney. In late April 1969, they met with Whitney director John Baur to express their concerns about the previous fall's exhibition of art from the 1930s that excluded black artists, and as a result of their negotiations over the course of the year tried to convince the museum to agree to a number of reparative solutions: to stage a major exhibition of work by black artists; to establish a purchase fund to buy works by black artists; to stage a minimum of five solo exhibitions of black artists in the small gallery off the main lobby of the building; to include more black artists in the Whitney Annual (the exhibition that would later become the Whitney Biennial); and to consult with experts in black art in the preparation of these and other shows.

Some of these were taken up: between 1969 and 1975 the Whitney held exhibitions of several African American artists in the lobby space, including Al Loving, Mel Edwards, Alma Thomas, and Betye Saar.

While most appreciated the Whitney's efforts, others noted the relegation of these shows to a space outside the main museum galleries. These shows came to an effective halt after 1975, with a change in museum leadership.

Other of the protesters' demands were taken up half-heartedly or not at all, as with a major show of contemporary African American art that was mounted in 1971 without the participation of a black curator or experts. The BECC was livid, not least because of the manner in which the curator, Robert Doty, went about his research and artist selection. "We say that the Whitney Museum has anti-curated its survey which results in misrepresentation and discrediting the complex and varied culture and visual history of African Americans," the BECC wrote. While Schoener's show failed because of a too-tightly curated vision of its subject, Doty's was marked by an equally disrespectful lack of critical standards borne from a lack of expertise. Baur made clear that his refusal to take on black curators was rooted in a desire to not relinquish the kind of power that the BECC was demanding, even if couched in the idea of the need to uphold a universal standard for American art: "It's more than a matter of our wanting to take full charge of our own show. The Coalition stands for a kind of separatism I don't believe in. The black artists don't have backgrounds in tribal art—they're part of the American experience.

And they should be judged by the same yardstick as other American artists."

•

Schoener had described his aspirations for *Harlem on My Mind* as follows: "The individual who responds to an experience becomes as important in the communication process as the one who organizes it. In other words, the audience itself becomes a creative force. . . . This suggests a new aesthetic hierarchy." Substitute "protesters" for "audience" and you have some sense of what the artists, curators, administrators, and organizers who gathered to form a response to *Harlem on My Mind* achieved. They allowed something to bubble up to the surface that was kept largely hidden until that point: the museum as an institution has a role in policing boundaries—keeping people out as much as welcoming them in, especially along the criteria of race, and even despite (and sometimes through) the language of community outreach, diversity, inclusion, and the need to have "difficult conversations." And in that sense, the protesters' travails would never be over.

Benny Andrews expressed the unfinished work of protest when he recalled, "The BECC set out in the talks with the Whitney Museum to show that we could sit down with 'them' and deal in measured tones with the inequities accorded the black man in this society—and dammit we did. . . . We left no promises, and made

no requests, but we know we'll be back to the Whitney Museum of Art someday—as painters and sculptors, we hope; not as stand-in curators and vocal spokesmen for the black man."

NOTES

1 A lot has been written on *Harlem on My Mind* and its role in galvanizing black art activism between 1967 and the mid-1970s. I am retelling a story accounted in much greater detail in the following works: Bridget R. Cooks, *Exhibiting Blackness: African Americans and the American Art Museum* (Amherst: University of Massachusetts Press, 2011); Steven Nelson, "The Museum on My Mind," in *New Histories*, ed. Lia Gangitano and Steven Nelson, exh. cat. (Boston: Institute of Contemporary Art, 1996), 24–30; Caroline Wallace, "Exhibiting Authenticity: The Black Emergency Cultural Coalition's Protests of the Whitney Museum of American Art, 1968–71," *Art Journal* 74, no. 2 (Summer 2015): 5–23; and Mary Ellen Lennon, "A Question of Relevancy: New York Museums and the Black Arts Movement, 1968–1971," in *New Thoughts on the Black Arts Movement*, ed. Lisa Gail Collins and Margo Natalie Crawford (New Brunswick, NJ: Rutgers University Press, 2006), 92–116. In addition, I have drawn upon the meticulous archival material contained in Susan Cahan's *Mounting Frustration: The Art Museum in the Age of Black Power* (Durham, NC: Duke University Press, 2016) and the lively story recounted by Steven C. Dubin in *Displays of Power: Controversy in the American Museum from the Enola Gay to Sensation* (NYU Press, 1999).

2 Cooks, *Exhibiting Blackness*, 53

3 Jozefa Stuart, "How Hip Should a Museum Get?" *Life*, Feb-

ruary 21, 1969, 14.

4 Allon Schoener, *Harlem on My Mind: Cultural Capital of Black America, 1900-1968*, fourth edition (New York: New Press, 2007), n.p.

5 Dubin, *Displays of Power*, 25.

6 Lennon, "A Question of Relevancy," 102.

7 Lennon, "A Question of Relevancy," 95.

8 Those involved in black activist circles knew the phenomenon well. The poet and activist Ishmael Reed pointed out the hypocrisy when he referred to the "many pimps of misery . . . [who] although publicly 'crying the blues' about Vietnam have never given a black artist a Hershey bar let alone invite[d] him to set up his work in a gallery." Benny Andrews, a painter and activist who would emerge as one of the central figures in the protests around *Harlem on My Mind,* recognized the opportunism in the Met's sudden embrace of African Americans, noting, "We're a trend like pop and op [art]. . . . We're the latest movement. Of course, like the others, we may be over in a year or two."

 In his preface to the catalogue of *Harlem on My Mind,* Hoving confirmed the suspicions that the show was part of this "radical chic" moment. His essay recalls his privileged upbringing devoid of any black people save a "friendly, always gay and warm" maid named Bessie and a "sour, moody, bitter, silent and mad" driver named Frank—figures who, as it turned out, Hoving made up whole cloth—and his mother's occasional visits to Harlem clubs: literal slumming.

9 Schoener, who was still working as the director of the Visual Arts Program at the New York State Council on the Arts at the time, would devote the greater part of two years to *Harlem on My Mind,* with NYSCA underwriting his salary for the duration.

10 There is an important caveat here: at the time, photography was not considered art, and photographers were not considered artists. When protesters complained that black art was

not included, they were speaking specifically of painting and sculpture. *Harlem on My Mind* did in fact include the works of a number of important black photographers, but as we shall see this ended up being an equivocal gesture.

11 Cooks, *Exhibiting Blackness*, 71.

12 Cooks, *Exhibiting Blackness*, 67–68.

13 J. Richard Gruber, *American Icons: From Madison to Manhattan, the Art of Benny Andrews, 1948–1997* (Augusta, GA: Morris Museum of Art, 1997), 141.

14 Dubin, *Displays of Power*, 37.

15 Hoving, *Making the Mummies Dance*, 172.

16 Dubin, *Displays of Power*, 34.

17 McGhee went on to found the James Van Der Zee Institute in 1969; it was briefly housed at the Met before being absorbed by the Studio Museum in 1978. Cooks, *Exhibiting Blackness*, 77.

18 See *Timeless: Photographs by Kamoinge*, ed. Anthony Barboza and Herb Robinson (Atglen, PA: Schiffer Books, 2016) and Maurice Berger, "Kamoinge's Half-Century of African American Photography," Lens Blog, *New York Times*, January 7, 2016, https://lens.blogs.nytimes.com/2016/01/07/kamoinges-half-century-of-african-american-photography.

19 Cooks, *Exhibiting Blackness*, 78.

20 Charles Wright, "Harlem at the Met: For Lap Dogs Only," *Village Voice*, January 30, 1969, 9.

21 Cahan, *Mounting Frustration*, 45.

Acknowledgments

This book has my name on its cover but is in fact very much the product of many conversations, virtual and face-to-face, that unfolded in the first half of 2017. This is especially so when it comes to Facebook, which functions for me as a shared space for brainstorming and stumbling toward thought. I would like to thank the many friends, "friends," and outright strangers whom I encountered in conversations about the Whitney Biennial in March and April 2017, but in particular American Artist, Caitlin Cherry, Andrea Chung, Christian L. Frock, Aaron Gemmill, Jackie Im, Tomashi Jackson, Swati Khurana, Justin Lieberman, Naeem Mohaiemen, Andrea Solstad, lauren woods, and members of the private group "Binders Full of People of Color in the Art World," all of whom debated heatedly but sincerely the very serious issues at play.

I took part in these debates while working with the education team at the Whitney Museum of American Art, conducting monthly discussion groups on the issues of structural bias and inclusivity. Kathryn Potts, Megan Heuer, Anne Byrd, and all their colleagues have been incredibly generous and forthright interlocutors. Around this time, too, Catherine Morris

and Rujeko Hockley invited me to write about Third World Feminisms in the catalogue for their essential exhibition *We Wanted a Revolution: Black Radical Women, 1965–85*, leading me to think about the protests around Artists Space in 1979. It was in July 2017, when Paul Chan approached me with the idea that I should write a book for Badlands Unlimited, that these threads started to coalesce into something more tangible. Over the course of an hour's conversation the idea for these pages was born; Chan and his colleagues, Micaela Durand and Parker Bruce, have offered terrific support, encouragement, comic relief, and canny strategy in the impossibly quick process of bringing it to fruition. Ania Szremski, Claire Lehmann, and Tiffany Barber contributed their meticulous fact-checking, copyediting, and researching skills respectively to the endeavor, and I thank them for it. I'm grateful that Parker Bright and Pastiche Lumumba, two artists at the center of the Whitney protests, have contributed artwork, including three original drawings by Bright that introduce the three acts of the drama narrated in the preceding pages.

Maurice Berger, Michael Brennan, Christian Haye, Simone Leigh, Steven Nelson, Dushko Petrovich, Robert Ransick, and Margaret Sundell have all provided moral support, guidance, and wise counsel, for which I am most thankful. Hannah Black and Janet Henry were generous with their time and oriented my thinking in crucial ways, although this account speaks on neither of their behalves. And my daughter, Priya

D'Souza—my little social-justice warrior, who has put up with my social media habit for all these years with varying degrees of patience and good humor—gave me all the motivation I needed to tell these stories.